Digital Cinematography

LIMITED WARRANTY AND DISCLAIMER OF LIABILITY

Digital Cinematography

Ben de Leeuw

AP PROFESSIONAL
AP PROFESSIONAL is a division of Academic Press

Boston San Diego New York
London Sydney Tokyo Toronto

United Kingdom Edition published by
ACADEMIC PRESS LIMITED
24-28 Oval Road, London NW1 7DX

ISBN 0-12-208875-1

Printed in the United States of America
97 98 99 00 IP 9 8 7 6 5 4 3 2 1

For Jim Steerman and Ken Robinson,
who taught me to see through the lens.

Contents

Contents

Chapter 8

Chapter 9

Chapter 10

Chapter 11

Acknowledgments

Many people have given me support throughout the writing of this book and I thank them all. Specifically, I want to thank the following folks: Intergraph for their gracious loan of a TDZ 300 workstation, without which I would still be rendering, and especially Clive Maxfield for his support and advice; Wendy, John, and the staff at The Brainwash for keeping me caffeinated; cast and crew at Jack's for giving me somewhere to blow off steam; Kelly Dove for giving me the first break; and, of course, Mom and Dad for supporting my unusual career choice in the first place.

Foreword

Call it an art, call it a craft—either way you look at it, digital cinematography is a highly skilled practice that takes time and effort to master. This book is intended as a launching point, a presentation of the basics from which you can build. There is no end to learning digital cinematography or any other art—you refine your skills continuously. Hopefully when you have completed this book you will have the foundation for a craft that you will spend a lifetime mastering.

In writing this book I have struggled with how to use words to teach a purely visual medium. My solution included using as many images as possible to illustrate the text. Nonetheless, words and static images do not have the same teaching value as moving imagery, so I have included some moving images on the CD-ROM. By necessity the .avi files included are of much lower resolution than would be ideal, but they do show the medium as it should be seen—in motion.

I hope this book is illuminating and helps you to find the same joy I experience when creating a well-crafted image.

Ben de Leeuw

Digital Cinematography

Digital Cinematography introduces the concepts of traditional cinematography to computer graphics (CG) animators, many of whom have no experience in working with lights and cameras outside the digital realm. The book explains the concepts and techniques used in motion picture cinematography in terms CG animators understand. It examines the tools available to the digital cinematographer, and how they differ from those of traditional filmmaking, but the primary focus is on the techniques for creating motion picture visuals in the analog world, and how to use them in creating computer graphics.

Where to Start

Most of the chapters can be regarded as independent tutorials, each dealing with a different technique and the tools it requires. The chapters do not need to be read in order and you should feel comfortable jumping around from chapter to chapter, reading those that have immediate relevance. However, each chapter introduces new concepts and methodologies that are by no means limited to that particular subject, and I recommend reading through all the chapters, as the tools demonstrated for one technique can be applied to others. You may find that a tool or method covered in the chapter on characters may be just the thing you need for an architectural walk-through.

The first three chapters constitute an introduction to the tools and working methods of the digital cinematographer. If you are completely unfamiliar with the art of cinematography, I recommend reading them before you move on to the rest of the book, regardless of the order in which you read the remaining chapters.

Playtime

Each chapter contains one or more Playtime sections—suggested exercises to familiarize you with the tools and techniques covered in that chapter. They suggest a scene to work with and some visual techniques to experiment with in that scene. The choice of loose recommendations, as opposed to step-by-step tutorials, is motivated by the nature of digital cinematography. There are no right and wrong ways to create the visual style of an animated cartoon. As a digital cinematographer you should incorporate a sense of play and experimentation in your work. The exercises give you suggestions on where to experiment with a particular visual style and what

results you can achieve with a specific tool, but the specifics are left to your discretion. Use these exercises as a chance to play freely and to develop your own methodologies rather than looking for canned solutions.

Tips and Jargon

Throughout this book, as needed, tips about technique and tools and definitions of professional jargon have been included. They are set apart from the main text and identified with specific icons. Jargon (see icon at left) presents specialized cinematography and computer graphics terms that may not be familiar to everyone. Tips (see icon at left) suggest ways of working with tools and avoiding pitfalls that might occur when creating the effects covered in a chapter.

Presenting Images

The art of the digital cinematographer is in presenting images. There are many aspects to making a film or cartoon, but the one addressed here is the visually compelling presentation of the subject. Creating dynamic imagery is not just a matter of adding some light and pointing a camera; you must carefully orchestrate all your cinematic tools to create images that are both compelling on their own and appropriate to the narrative. This involves fitting tools and techniques to the job at hand and creating a new method for working with each new project. Digital cinematography is a craft, and as the craftsman you are responsible for knowing the medium well enough to tailor the look of each film to fit its aesthetic and thematic demands.

Many factors affect how a viewer perceives an image. The narrative content of the image, the base on which the cinematography is built, is the most obvious. If the script calls for a shot of Jack fetching a pail of water, the shot must be of that action; a shot of Jill fetching the water, even if exquisitely beautiful, fails to convey the story. The basic thing you need to accomplish in presenting images is to convey the narrative. Even in forms like music video, which often have no linear sequence of events, the story is the foundation for the cinematography. The narrative may not conform to a traditional story line, but even a seemingly unrelated series of images creates a loose narrative simply by their sequential presentation. The same concerns are involved for the cinematographer whether the story is an adaptation of *War and Peace* or a perfume commercial. In either case you examine the material to be filmed and determine how to best use the tools of the trade to make the images reinforce the flow of the story.

When planning and composing a shot, you must take many factors into account to predict how the audience will react on a visual level. Of course, you are only guessing and you might be wrong, but the craft of the digital cinematographer is to make educated guesses on how viewers will respond to visual elements. The lighting can suggest a mood; the way the camera treats a character intimates details about her personality. Many details don't seem to have a direct effect on how an audience will perceive the story, but in truth they are the very factors that guide them. What difference does the color of the lighting on the character or the lens in the camera have on telling a story? It doesn't change the content of the narrative, but does affect how the viewer interprets that narrative.

Consider a Shakespeare play. It can be presented in a variety of ways: in full historical costume or set in modern day; with real locations or a bare stage. But however varied the trappings, the story at the core remains the same; what changes is the context. By changing the context you affect how the audience perceives the narrative. When *Romeo and Juliet* was remade as *West Side Story*, the plot remained mostly unchanged, and yet the flavor of the story was

very different. Your job as a digital cinematographer is to add flavor to the story. A little backlight here, a wide angle lens there, a simple fog effect, and, *voilà*, the images are transformed from a simple narrative sequence into a four-course visual feast.

Film Language

Film has a distinct language of its own that is visual rather than verbal. Like a verbal language, it has grammar and dialect, and there are many different dialects, sometimes so far apart that they seem unrelated. These variations are due to cultural differences between the storytellers, but at the core is the same set of responses shared by viewers all over the world. The way a Hollywood-produced movie tells a story might be very different from the way a film student tells it, or a French filmmaker, or an African filmmaker, but they all use the same tools. There are certain visual responses that are common to everyone regardless of culture.

We all share certain automatic responses to visual stimuli. When you look at a picture, you will immediately seek out the brightest light, the color red, movement, and the human figure. If you put a character in a scene, that is where people will look. If you have two characters, one dressed in brown, the other in red, the viewer's eyes will first be drawn to the red one. Lighting and positioning of the camera are, at their most basic, an attempt to lead the eyes of the viewer to where you want them to look.

Visual cues let the audience know which details should receive particular attention. If your film opens with the protagonist in a crowd, you want the viewer to know which member of the crowd the story will be focusing on. You may choose to dolly in on that character slowly, but even before you begin closing in, you want to give the audience a clue that this is your subject. Put a red shirt on him amidst a crowd of people dressed in muted tones, and he stands

out. Forget the red shirt and use twice as much light on him as on anyone else, and he stands out again. Have him moving against the crowd, and once again he stands out. Each of these tools—color, light, and movement—will draw the eye of the viewer.

Visually composing a film is not like writing an essay for your tenth-grade English teacher. If you use unusual language and grammar you will not fail the semester. Cinematography is more like creative writing—it is okay to deviate from the standard language, but you should do it intentionally and not out of ignorance. For example, the rule in motion pictures is that the camera should remain invisible. Characters should never acknowledge its presence because it breaks down the illusion. Figure 1.1 shows the cat looking toward, but past, the camera as if he were looking at something just

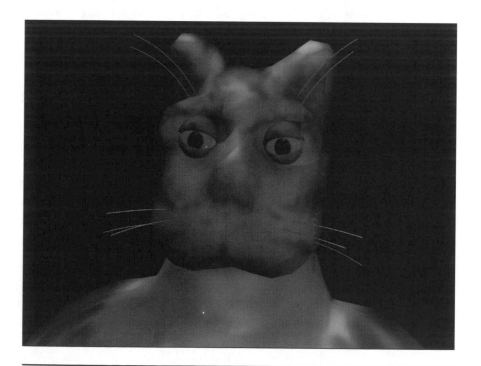

FIGURE 1.1

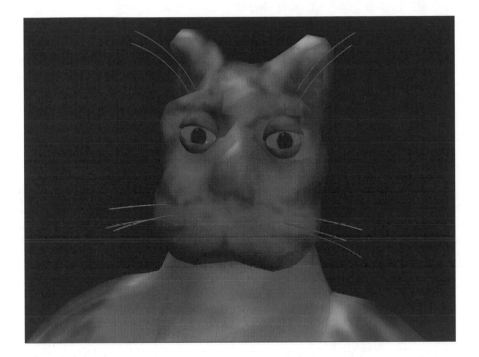

FIGURE 1.2

over the cameraman's shoulder. Figure 1.2 has the cat looking directly into the lens. Note that the change in the position of the eyes, though very small, still noticeably changes the focus of the cat's vision. The cat has acknowledged the camera's existence. This rule is broken frequently in films; it isn't uncommon for characters to address, or at least mug, for the camera. Such nonstandard grammar is often used by filmmakers to emphasize what the character is doing or saying. Knowing the rules allows the filmmaker to break them consciously to elicit a particular response from the audience.

Aesthetics

When you begin planning the look of a film or animated piece, it is important to figure out what the guiding principles will be. You may know you are working on a cowboy film, but is it a minimalist affair, like a spaghetti western, or an epic, like a classic John Ford movie? These are questions of aesthetics. Beyond the specific effects you plan to use, you must plan how to use the visuals in support of the narrative. The aesthetic choices you make form the basis for all decisions about how to illustrate the film visually. If the choice is to make the film simple and uncluttered, you may want to use simple lighting designs and a straightforward, static camera position. On the other hand, if you choose to make the film in a baroque style, the lights will be complex and layered, and the shots will be framed dramatically. The choice of aesthetic determines how you will use your tools to implement the film visually.

Work Principles

As you create images you should always keep in mind three guiding principles: simplicity, consistency, and planning. These are rules not of film language but of the art of cinematography. Approaching a project with them in mind helps you create aesthetically powerful images efficiently.

Simplicity

No matter what kind of film you are making, whether a slick action/ adventure or a gritty human drama, your job is to create the visuals

as simply as possible while maintaining the style of the film. Strive to be elegant with your visuals; that is to say, find the simplest, most effective method to create the look of the film. As you plan the look continually ask yourself, "Is there an easier way to do this? Can I get the same effect from a simpler technique?"

Start from the most basic, and add layers of effect as you need them. Begin, for example, by setting up two or three lights that affect your whole scene. Refine them until they begin creating the visual concept you have in mind. Once this overall structure is created, you can begin adding other lights and refining them further to create a more visually complex image. This approach can save you a lot of work because it allows you to evaluate the image as each new cinematic element is added. Sometimes you will achieve the look you want with less work than anticipated. You may find that a scene you had thought would need a complex setup works better with just a couple of lights.

Consistency

It is important to have a consistent look to a piece. If you use one visual style for the first scene and another for the second, you create an incongruity that can destroy the film's flow. Whether a feature or a 10-second commercial, a film is a window into another world. What the audience sees through this window should remain consistent because this makes the world they are peering into appear consistent and therefore credible.

If you choose to make a film that is dark and full of contrast, the credibility of that world will be diminished if suddenly, in the middle of the film, there is a bright, evenly lit scene. Figures 1.3 and 1.4 are frames from a dark, gritty detective movie. Though they exhibit different uses of light, they remain consistent in overall look and flavor. Figure 1.5, though featuring the same character, has a

FIGURE 1.3

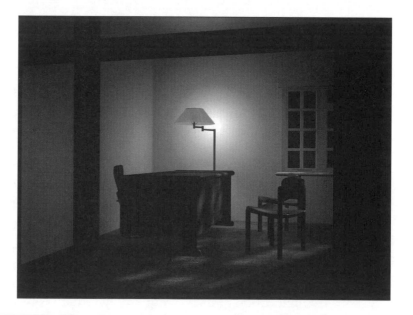

FIGURE 1.4

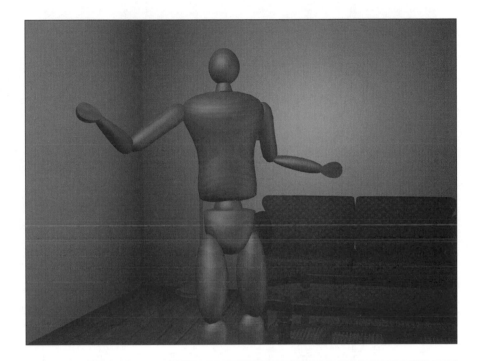

FIGURE 1.5

very different visual style. The lighting is bright, and there is very little contrast in the scene. If this scene were in the same film as the others, it would break the continuity of the visuals and as a result erode the viewer's belief in the film's reality.

People are willing to believe in the reality of a film (at least for a couple of hours) if the film is internally consistent. As long as all the characters and all the scenes follow the same set of rules, viewers are prepared to accept rules that differ from those of the real world. If the rules seem to apply only haphazardly, viewers are not likely to buy into the film, regardless of how much it operates like the real world.

Planning

The key to working effectively and efficiently as a digital cinematographer is preplanning all your work. That doesn't mean you should be closed to ideas that come up during production, but you shouldn't rely on them. It is important to have a firm grasp on the aesthetics of a piece, and how the visuals relate to the narrative, before you begin production. If you don't know where you are going at the beginning, you may end up completely changing direction in the middle of a project and as a result lose days or even months of work.

In planning the look of your film, test renderings can be an invaluable tool. By creating test images that reflect different approaches to the cinematography, you give yourself and others involved in the production a chance to see how a concept actually works in that specific production, rather than relying solely on theory. Figures 1.6 and 1.7 show two treatments of the same scene. Neither look is better, but each creates a different feel. Seeing concrete examples of possible visual styles for the film allows you to evaluate them, both individually and in comparison with each other. This comparative analysis lets you choose from among the test images the style that best fits the film, or the pieces from each that will be combined to create it.

There is a long tradition in the world of computer graphics (and the art world in general) of producers or other bigwigs changing the look of a project halfway through production. Planning the look, and rendering test images, will not eliminate this tradition, but it might help to avoid it by giving everyone a picture of what the piece will look like before real production begins. (Rendering your producer, say, speechless might actually eliminate the problem, but is not usually looked on kindly by said producer.)

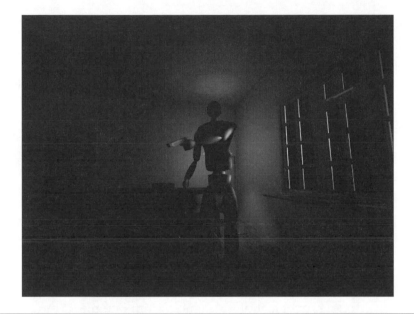

FIGURE 1.6

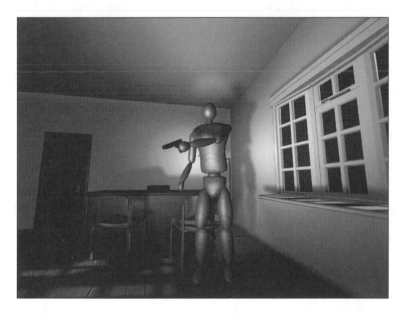

FIGURE 1.7

Reference Material

Throughout this book you will be introduced to many of the tools and concepts used in digital cinematography, but technical knowledge is not enough. You must study the history of the craft by observing the work of others. Imagine a painter who could use a brush but had never studied the work of other artists—he might spend an entire lifetime inventing techniques that had been around since the Renaissance.

In conceiving a visual style for your film, you will want to look at reference material to spark ideas. You are not likely to find the complete look you want in someone else's work, as each project has its own needs and therefore its own style. What you will find are bits and pieces of the overall style you're looking for. You may like the movement of the camera from one piece, the lighting from another, and the color scheme from a third. It is to your advantage to compile as much reference material as possible, as this gives you a greater wealth of style from which to choose your elements. Study the work of other cinematographers, both digital and traditional, as well as the work of photographers, painters, and other artists.

Watching Movies and TV

Chances are you already watch television and go to the movies, but to study these media you need to look at them in a different way. When you watch a movie, you gather in the whole experience. In being so holistic you probably don't pay the attention needed to learn from it because you become wrapped up in the story. Analyzing a film is best done by watching it several times so you can get past the plot and focus on the visuals. Which films to watch is a personal choice; it depends on what kind of visuals you are studying.

Choose a film that looked good to you, with cinematic flavor similar to the one you are trying to create. Don't worry about the plot or the actors or the director. Screen the film, making notes on which scenes worked for you visually, the overall impact of the cinematography, and specific techniques or effects you want to study. Watch those scenes again and again. Pause the tape and analyze the frame; try to figure out how the lights were set up to create that particular look. Make note of what elements compose that specific visual style. Is the focus deep or shallow? Did the cinematographer choose a wide lens or a long one? Is the camera invisible, or is it part of the scene? If some of these terms are unfamiliar to you, don't fret—they will be explained in later chapters. The key is to focus on what the visuals add to the film and how the tools of the cinematographer are used to create them.

As you watch films analytically, there will be techniques you find particularly effective and others that break the illusion. Some of this is a matter of taste; what works for me doesn't necessarily work for you. Other shots don't work because they aren't visually effective. Don't discount bad cinematography as a source of learning. It is just as important to know what doesn't work as it is to know what does.

Sometimes appreciating a visual style involves a learning process. Just as we learn to understand a verbal language, we also learn to understand the language of film. When moviegoers in the late nineteenth century saw a film of a train coming toward them, it is reported that many people fled the theater in fear. These viewers were not stupid; rather, they hadn't learned the language of film and could only interpret the train in terms they already knew. Similarly, close-ups, which show only part of a character's body, were originally dismissed by filmmakers on the assumption that audiences would be horrified by the disembodied heads on the screen. Today the close-up is part of the standard film vocabulary. Viewers have been educated visually by the films and TV they watch. In choosing an approach to the visuals of your film, take into account the visual language familiar to your intended audience. Cinematic grammar that makes perfect sense to the MTV generation may completely

confound an older audience. If you use the language in a manner familiar to your target audience, you will create a film that resonates with them visually.

Other Reference Sources

Film and television are not the only sources of reference. Any visual art can exhibit qualities that you may want to use in your cinematography. Painting, for instance, has been around for millennia, and its wealth of reference material is staggering. Just as in cinematography, painters must choose how they use light in their work to best complement the subject. Your local art museum probably contains more examples of visual styles and approaches to lighting and composition than your local video store. Just because a painting or a photograph doesn't move, don't dismiss it as reference; movement is only a small part of the equation.

The real world can provide reference as well. Many times you will draw inspiration from a real sunset or from the way the light streams through the window in your bedroom. Reality is the purest reference source you can use, whereas art is only a simulation or interpretation of what exists around you. You can approach reality as reference material with the same analytical methodology that you use to examine art. When the light glistening on a frozen puddle catches your eye, consider where the sun is and how much light is bouncing off the snow, and what the colors are. If you use an analytical eye, any visual experience—movies, paintings, or reality—can teach you and give you inspiration.

Wrap-Up

This chapter has introduced digital cinematography as an art form. It has given you a brief overview of the craft of creating powerful visuals for your film or cartoon. The next two chapters will introduce you to the basic tools and techniques of the digital cinematographer. Chapter 2 focuses on lights and the general theory behind their use. Chapter 3 deals with the camera and how its position and other variables affect your images. These two chapters, along with the one you have just read, are the foundation on which to work through the rest of the book. The subsequent chapters examine different tools and techniques and how they create a specific effect or style. All of these tools and techniques are variations on the basic principles laid out in these introductory chapters. Once you are familiar with the basics, you can approach the remaining material in any order, focusing on the topics that are most immediately important to you.

Introduction to Lighting

When you see a well-crafted image, you know it looks good but you may not be aware of what ingredients contributed to its visual potency. That is the sign of a gifted cinematographer: The craftwork is not immediately obvious because it is well blended with the content of the image. In learning the tricks of the cinematographer, you will learn the ingredients that combine to create a strong visual image and you will learn how to use the tools of the trade to combine and fine-tune those ingredients.

There are a few basic tools or tool sets you will use as you explore the art of cinematography. The most important set of tools in shaping an image is the lights. It is the placement and intensity of all the lights in a scene that create a visual mood. A cinematographer, or in this case a digital cinematographer, is a painter who uses light as his paint and the scene as his canvas. There are many aspects to the lighting of a scene. You must consider position, intensity, and the type of light you use. Each light has a different function and usually has different attributes. Some lights are used to light the main character, while others light the set. Some lights will cast shadows, and some will project images. The amount of control you have over lights in the computer would make most traditional cinematographers jealous. The ability to so accurately control the color, intensity, and range of a light is beyond the reach of analog lights operating under the rules of real physics. As a computer-based cinematographer, not only can you control these attributes easily, but you can do things that are simply impossible in the real world, such as have lights that cast no shadow or shine only on a specific object.

In this chapter you will begin to learn the fundamental concepts of composing a scene with light. You will learn about basic lighting positions and about some of the lighting instruments you have to work with. You will do this by following along step by step in the lighting of a simple scene.

Lighting Instruments

The first thing to do is become familiar with the basic lighting instruments you will be using. Instruments is a term stolen from real-world cinematography; it refers to the actual physical devices

that create the light. I use the term instruments in this book to refer to the computer-generated equivalent to the real thing, represented by an onscreen icon and a set of controls. There are only a few basic instruments in the world of digital cinematography because each one has a wide variety of settings.

Ambient Light

Ambient light is the most basic light you can work with in computer graphics. However, it is not really light at all; it is a setting that defines the maximum level of darkness in the scene. Ambient light has no instrument associated with it; it is a global setting for the whole scene. The higher you set the ambient light, the brighter the darkest parts of the scene become. Ambient light should always be kept very low, as it will flatten the look of the scene if it is turned up too high.

Omni Lights or Point Lights

Omni lights are very simple. A point is defined in space, and an intensity of light is defined as being emitted from that point. When creating an omni light, you create an icon that specifies where the light is originating and light is cast spherically from that point, illuminating in all directions. The settings for an omni light consist only of intensity and color. All the subsequent lighting instruments follow this same basic creation method of defining a point in space, intensity, and color, but each adds other functions.

Spotlights

Like omni lights, spotlights are defined in space and then adjusted for intensity and color. With the spotlight, however, come more features. Directionality is the most important added function of the spotlight. Rather than casting light in all directions, a spotlight casts light on one vector only, creating a cone of light. The cone of the spotlight consists of a hotspot and a falloff. The hotspot is the area in the center of the light that is at full intensity, casting the full amount of the light you have defined. The falloff is an area surrounding the hotspot that defines the area in which the light reduces in intensity from full blast to zero. If you are at all familiar with spotlights in the real world (c'mon, you remember those old Fred Astaire movies), you will probably recognize that area at the edge of the spot where the light falls off to darkness. The shape of the spotlight's cone is determined by the diameter of the falloff and the distance from the instrument to the subject. Other modifiers can often be applied to spotlights, such as shadow casting and image projecting. These will be covered later in this chapter.

TIP: When you create a spotlight, always make the falloff a little larger than the hotspot. When you are making a tight beam of light, such as a stage spotlight, it can be tempting to make the hotspot and falloff the same size. The problem with this approach is one peculiar to computer-generated images. If there is not at least a small area of falloff for a spotlight, the edge of the circle will often appear jagged or stair-stepped; this is called aliasing.

JARGON: *Aliasing* is the jagged look created where lines of pixels with very different intensity or color values meet. Because the image is made up of a finite number of square pixels, when blocks of adjacent pixels have very different values the rectangular nature of each pixel is emphasized by its contrast to the pixel next to it. This is particularly prominent in long diagonal lines.

Antialiasing is a process that smoothes the transition from pixels of one value to pixels of another by creating intermediate values between them. Antialiasing is applied, automatically by most programs, to an image after it is rendered.

Directional Lights

Directional lights are completely parallel light sources. The light rays coming from a directional light do not converge at their origin. The best example of a directional light in the real world is the sun. The sun is so large and far away that the light rays that reach the Earth are all parallel to each other. A directional light will be represented onscreen by a rectangular icon to show the plane of the light and usually a directional arrow to show which way the light is being projected. Directional lights can usually be used to cast a shadow but only within a limited area.

Lighting Positions

In lighting a scene there are several standard "positions" for lights. Each has a name associated with it that describes the function of that light. The position of a light does not specify what type of instrument is used. What is specified is the type of illumination that particular light gives the scene. The combination of these lighting positions is what creates a complete lighting setup. While many lights may be used in a scene, most will fall into one of the basic lighting positions. More than one light may be used for a given position, and one light may be used for multiple positions. Most scenes will not use all the lighting positions but only the ones needed for that particular situation. There is no set rule for which positions need to be in any given scene except to make it look right. In the lighting of a scene, each of

the lighting positions that follow should be considered both individually and in combination with the other lights in the scene. These are only the most basic positions; there are many others used in specific circumstances. Other lighting positions will be covered throughout the book.

Key Light

The key light is the main source of illumination in the scene. Its function is to provide the primary illumination for the subject or focus of the scene. Other lights are used to fill in areas not illuminated by the key light. The majority of the illumination in a scene may come from other lights, but the key is the primary light because it illuminates the subject, the focus of the scene. Often this light is "sourcy"; that is, it has an onscreen or implied source that is easily identified. Light simulating a ceiling light or a window is considered sourcy. In general, the key light is positioned in front and to the side of the subject based on the position of the camera.

Fill Light

The fill light is used to add a small amount of illumination in the dark areas left by the key light. Usually you want some definition in areas that are dark or in shadow. The fill light is almost never more than half the intensity of the key. Often it is less, depending on the look and style desired. The position of the fill light is usually a little less than 180 degrees rotated from the key light on the ground plane. If the key light is set high, the fill light will be set low.

Back Light

The back light is used to separate the subject from the background. This is often an unmotivated light that has no logical source. The back light is positioned a little less than 180 degrees from the camera. The light is intended to add a thin line of illumination to the dark side of the subject that will delineate it from the background. This light is not intended to illuminate the features of the subject but only to visually separate it from the background.

Set Light

Surprisingly, the set light is used to illuminate the set. Most of the lights in a scene are for lighting the subject, but usually the subject exists in a setting that also needs light. Lighting the set separately allows you to highlight the portions that are relevant to the scene and separate the background from the subject. The set light is usually less intense than the key light.

Take a Look

This example will look at the specifics of creating a simple lighting setup. Each light used in the scene will be examined individually and as part of the overall effect. The technical and artistic purpose of each lighting position will be explained in the context of lighting this scene.

Meet Woodrow, our volunteer subject (Figure 2.1). In this shot Woodrow is sitting by himself at a table, perhaps in a restaurant. The overall tone of the image is dark, the background is black, and the shadows are heavy. You are under a deadline and don't have time to do a lot of fancy lighting. What is needed is a quick, simple setup that will maintain the dark mood of the scene.

This lighting setup is very basic. To maintain the dark mood with shadows and high contrast, this scene is lit with hard light. Hard light is strong, directional light that creates high contrast between the lit and unlit portions of the image. The simple setup consists of only three lights. The key light is the main light in the scene—it provides most of the illumination. The fill light is a secondary light that adds a lower level of light to those areas not illuminated by the

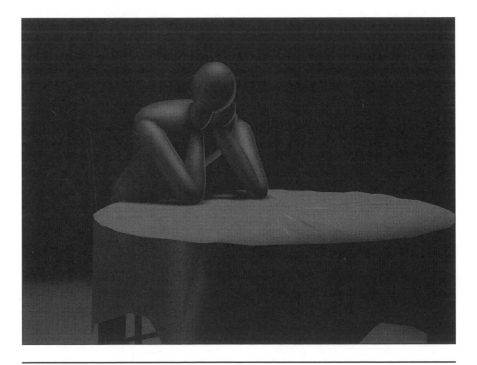

FIGURE 2.1

key. The back light adds defining lines of light to the edges of the objects in the scene.

Setting It Up

To understand how each of the elements of the lighting setup contributes to the overall image, it is necessary to look at them individually. When cinematographers light a scene, they often use this trick to help with the composition of the light. Turning off all the lights but one makes it clear exactly what is being illuminated by that specific light. Seeing what each light does on its own helps you to understand how it interacts with the others.

In addition to how the lights interact with each other, it is important to see how they interact with the camera. Although the camera will be covered in more depth in a later chapter, it cannot be excluded from even this most basic of exercises. The camera's interaction with the lights is important because it is the camera that defines the canvas that you are working on. The only thing that matters is how the light looks within the frame of the camera, as that is all the viewer will ever see.

Camera

It usually makes sense to set up your camera before you begin lighting in earnest. After all, it is the view through the lens of the camera that you are lighting. In this scene, the camera position is very simple: a straight-on shot with no extreme angles or lens distortion. The framing of this shot is considered a medium shot, because approximately half of the main subject is visible in the frame.

The subject is framed with his head slightly left of center. The table fills the bottom right half of the screen, creating a balance with the subject.

Key Light

Once you have a camera in place you can begin lighting. Look at the effect of the lights in the camera view. Only the camera view matters when you are positioning lights. If a light looks odd in the front view but works in the camera view, it is set up correctly.

The key light (Figure 2.2) will be the primary source of illumination in the scene. When you view the scene and ask "Where is the light coming from?" the answer is the key light. Other lights support the key light, layering their effect over it.

Woodrow is in a restaurant, so your first decision is to put the key light overhead as if it were coming from a ceiling lamp. You do not need to be totally constrained by the theoretical source of the light (the ceiling lamp); it is simply a reference to help you think about how to position the lights. You may choose to make the key light brighter than a lamp might be or off to the side rather than directly overhead. What is important is that it illuminates the subject in a way that achieves the desired effect. In this scene, the intent is to create a dark, moody feeling.

The choice of an overhead key light defines the figure, but keeps the face dark. The face contains a lot of information that viewers use to infer the mood of the subject. Even though Woodrow does not actually emote (or have a face), by keeping his face dark, a somber, mysterious mood is imparted. The key light illuminates the face and front of the subject. The effect is greater on the right side and also on the top.

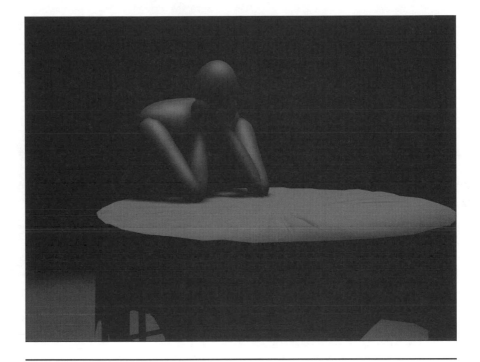

FIGURE 2.2

Fill Light

Now that you have a key light you can begin adding the other lights. These lights are intended to modify the effect of the key light without overwhelming it. The light most important in complementing the key is the fill light (Figure 2.3). The fill light's purpose is to soften the dark areas of the scene and add some illumination in the shadows. A fill light is usually no more than one-third the intensity of the key light, though that varies depending on the mood you are attempting to create. In this scene, the fill light is only about one-quarter the intensity of the key because the mood is intended to be dark.

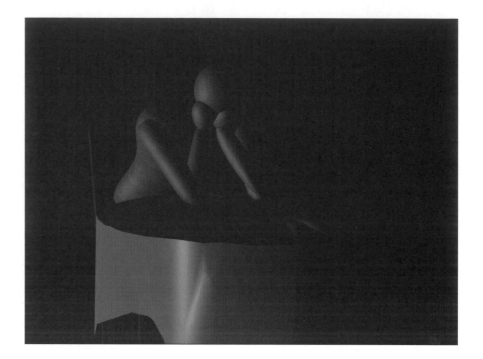

FIGURE 2.3

The fill light adds some light to the areas the key light doesn't hit. The intensity is much lower than the key light because you want to maintain the shadows even as you add light to them.

Back Light

The purpose of a back light is to separate the subject from the background. Areas of the subject that are not lit by the key or fill lights get lost in the background because in this scene, the background is black. You want the subject to be separated from the rest of the scene, but you don't want to add too much light. It is important

not to lose the overall contrast in the scene in your attempt to focus on the subject. The back light is a way of delineating the subject without losing contrast. It is placed opposite the camera to create a thin line of light around the dark areas of the subject. Usually the back light is not motivated by a specific light source in the scene. It creates an almost graphical element in the image that is not realistic, but is aesthetically effective because it keeps the viewer's attention focused on the subject.

The position of the back light is determined by the position of the camera and the key light. It is set nearly 180 degrees opposite the camera so that only a thin line of light will be visible through the lens. Usually it is also placed to complement the key light. If the key is high up, as in this scene, the back light should be placed low to catch those areas of the subject not within the scope of the key light. Woodrow's key light is very high, above him. The top areas on his body, like the top of his head and shoulders, are already well lit. The areas that are lacking in definition are the sides that are not hit by the key or fill lights. The left side of his head and body are lost into the background. Use the back light to add a thin line of illumination to the left side. The areas that were lost in the dark are now outlined with a thin strip of light.

Schematics

The schematics of the scene show the lighting and camera setup in a plan view. This view allows you to see the spatial relationship between each of the different elements in the scene. The combination of a top view and side view allows you to see both the position and the height of each instrument.

The top view schematic of this scene (Figure 2.4) shows the simplicity of the lighting setup. Look at the position of the three lights in relation to each other and to the camera and subject. In this view you

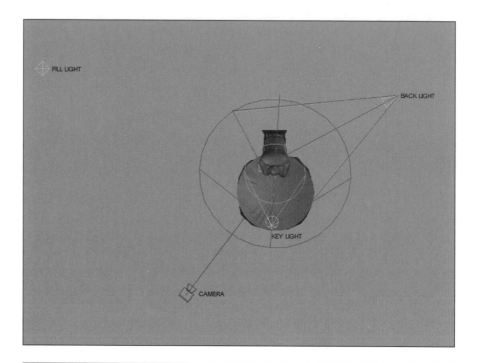

FIGURE 2.4

can easily see the relationship of the lights to each other and to the camera. Note the position of the back light in relation to the camera.

The side view schematic (Figure 2.5) shows the heights of the instruments and the camera. You can also determine the area that each light is illuminating. The cones extending from the lighting instruments show the range of that light. The omni light being used as a fill light has no range because it lights infinitely in all directions. Note the position of the back light in this view as it relates to the key light.

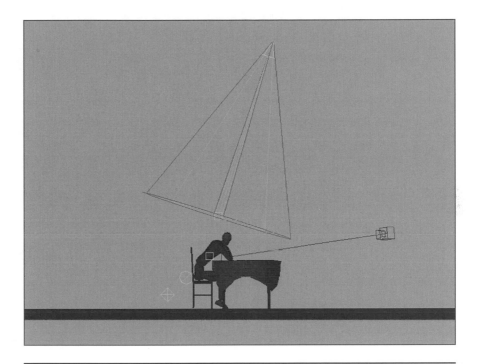

FIGURE 2.5

Take a Look

In this example you will expand on the principles outlined in your last exercise. A lighting position is added to the mix. The new position is carefully integrated into the complete setup. This scene is more complex, in terms of cinematography, than the last and adds another layer to the creation of the final image. Exploring the addition of a set to the scene reveals the relationship of location to composition and the tools needed to harness that interaction.

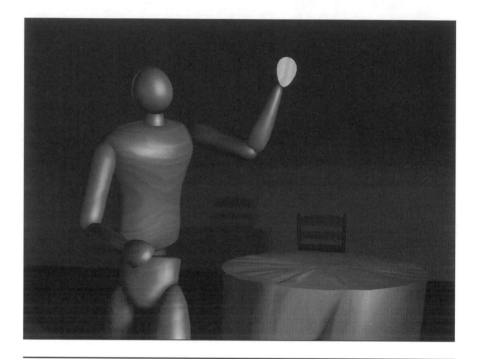

FIGURE 2.6

Here is another example of setting up a simple scene. This time we are adding a more complex set with walls and a new light to illuminate the set. The tone in this new setup is lighter than the last, exploring how changing the relationship of the lights to each other can affect the overall mood of the scene.

Woodrow has returned to his favorite restaurant (Figure 2.6). The management has done some remodeling, adding walls and changing the lighting. The overall mood in this scene is lighter than in the first setup. To emphasize the lighter tone, a softer light has been used in the scene. Soft light is diffuse light that illuminates the scene more evenly and casts less intense shadows. This scene isn't lit completely with soft light; there are still hard shadows and high contrast in the background. Woodrow, however, has a much softer, more even light than in the previous scene. The shadows on his body are less intense and smoother in their gradation.

Camera

As in the first setup, we have used a simple straight-ahead camera position. No extremes of angle or lens are used. The scene is composed with Woodrow filling the right side of the screen. The table on the left balances the composition.

Key Light

Because the management has changed the lighting in the restaurant, you must also change the position of the key light (Figure 2.7). This is a very traditional setup with the key light in front and only slightly

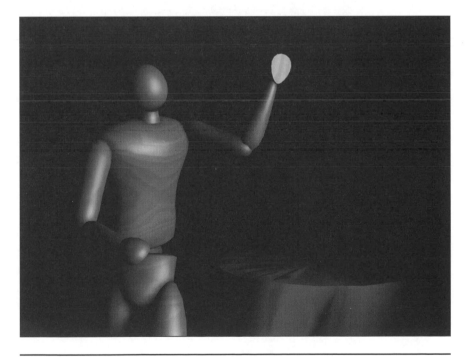

FIGURE 2.7

above the subject. The key is again a bright, shadow-casting spot-light, but it lights the subject more evenly than in the previous exercise. The reason Woodrow is more evenly lit is that in this scene the key light is in front of him, more closely aligned with the camera. With the key light and camera pointing in the same direction, the camera sees less of the areas of the subject not lit by the key.

In the analog world a diffusion filter would be placed over the key light in this scene to create the softer look. In the digital world this is not a practical solution because it is very difficult to create a semi-diffuse light source. In computer-generated imagery (CGI) you tend to work with hard lights such as the shadow-casting spotlight or with totally diffuse lights such as a point light, which does not cast shadows at all. To create the effect of a semi-diffuse light that casts very soft shadows, a combination of a hard and a diffuse light is the most effective approach.

The key light is slightly to the right and above the camera. It illuminates all but the rightmost and bottom edges of Woodrow's body.

Fill Light

The fill light in this scene (Figure 2.8) combines with the key to create the soft lighting effect. It fills in the thin lines of darkness left by the key. Because the key light illuminates most of what we see of Woodrow's body, the fill light is kept very low in intensity. It is positioned opposite the key light, though not quite a full 180 degrees opposite, and low to the ground. No attenuation has been used with this light, as it is also helping to light the set. Allowing the fill light to hit the back wall softens the effect of the set light, keeping the shadows from being too intense.

The fill light illuminates the right side and bottom surface. The intensity is low because it is being used only to smooth out the key light.

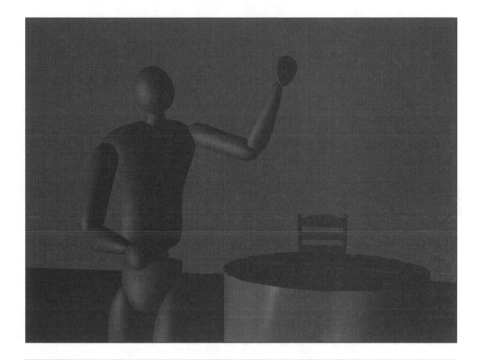

FIGURE 2.8

Back Light

The back light in this scene is very subtle. Woodrow is well lit by the key and fill lights and doesn't need much more separation from the background. The back light has been focused entirely on the head and shoulders. Even though the head is already well lit, you want to help it pop out from the scene a little more. In a scene where the subject is a figure, the head and face become the focus. This is because the viewer's natural tendency is to look at the face of a character. To emphasize this natural tendency, you add a little extra light to highlight the head. The back light here is of very low intensity and catches only the very top of Woodrow's head, but even that little extra light makes his head pop forward in the scene.

A spotlight with a very small hotspot is used for this light. The falloff restricts the effect of this light to only the head and shoulders area.

Set Lights

The set light (Figure 2.9) is used to light the set areas of the scene. The light from this instrument does not affect the subject at all. When lighting a set it is important to design the lighting relative to the lighting on the subject. The set should be a little darker than the subject so that the subject draws the eye of the viewer more readily. In this scene the set light is coming from the same general direction as the key light to create the illusion of a single light source. Because

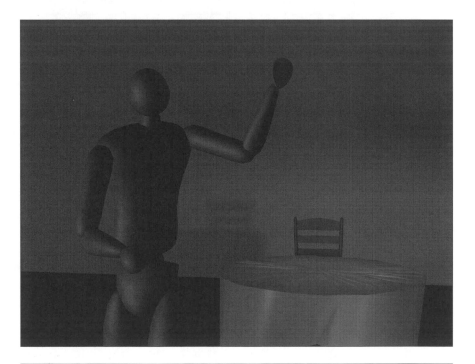

FIGURE 2.9

the fill light is casting some light on the back wall, the set light is concentrated primarily on the table. The light falls on enough of the back wall to create a shadow from the table and chair. A second set light is used to light the top of the table exclusively.

Schematics

The schematics for the second setup show how the set light is set up in relation to the other lights in the scene. Look at the positions of the lights in both the side view (Figure 2.10) and the top view (Figure 2.11) and see how they relate to each other. The cones of the

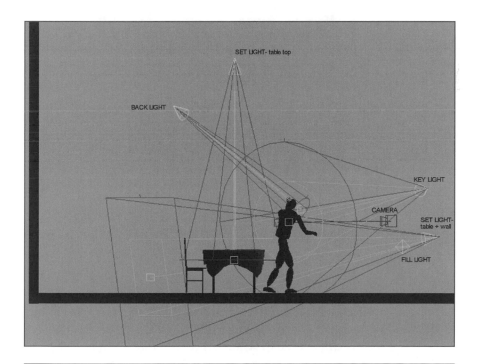

FIGURE 2.10

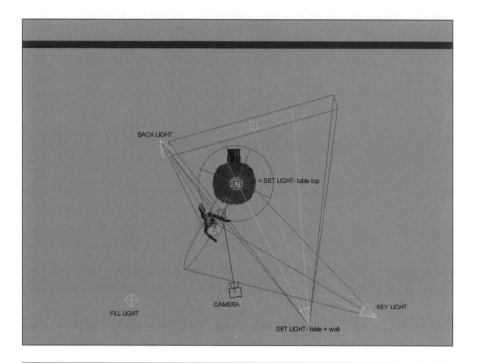

FIGURE 2.11

spotlights show very precisely where the light from each instrument hits the set and subject. Try looking at the positions of the lights in the schematics and then turning back to the main image (Figure 2.6) to compare how each position affects the light in the actual image.

 PLAYTIME

In the first part of this chapter you were introduced to a basic lighting setup. The simplicity of this setup does not limit the ways it can be used. There are hundreds of possible variations on the simple three-light setup. Try some modification to the lights in this scene and see what results you can come up with. Here are a few things you might try:

- Increase the value of the fill light. This will flatten the look of the scene.

- Increase the value of the back light. See how bright you can make the highlighted edge without distracting from the overall composition.

- Delete the back light and experiment with a naturalistic look. Cinematographers trying to create a very natural look often dispense with the back light altogether.

- Move the key light to a new position and adjust the other lights to complement this new position.

Motivated Lighting

The lights you use in a scene can be broken down into two categories: motivated and unmotivated. Motivated lights come from an apparent or implied source. The light from an onscreen lamp or window is motivated because you can actually see the light source. Light like this is sourcy. Light can be sourcy, however, without having an actual onscreen source. If there is an implied source for the light, such as a window that is off screen, the light is still considered sourcy because the viewer understands what the light source is even if it is not onscreen.

Unmotivated lights do not have a logical source; they are used for dramatic or aesthetic purpose only. Back lights are often unmotivated lights, used to delineate a subject even when there is no logical source for the light in the scene. In more stylized lighting setups, key lights and other lights may also be unmotivated. Horror films, for instance, use many lights that are not logical but that create the desired mood and effect.

Lights do not always fall easily into one category or the other. In the setups we have looked at so far, the lighting has been sourcy but only in a vague way. The light in the restaurant felt logical for the scene, but it would be hard to actually pinpoint what the source was. This vagueness points out the critical factor in the decision to use sourcy light or unmotivated light—does it work? If the light in the scene feels right and creates the atmosphere you want, then whether it is motivated or not is a moot point.

There is a two-edged sword in making the decision about the motivation of the lights. On the one hand, you don't want lights that make the viewer stop and wonder where the light is coming from. If the viewer is thinking about the source of the light, she is not watching the subject and you are actually distracting her from the scene. On the other hand, you do not want to get so tied to using realistic, sourcy lighting that you allow it to keep you from making the best aesthetic decisions. The purpose of the lights is to show the viewer what you want her to see in the scene. If this is best accomplished with lights that have no logical motivation, so be it. Your job is to present the scene in the most effective way you can that remains true to the mood you are creating.

Light Modifiers

So far we have looked at setting up lights in terms of position and intensity, but there are other attributes that can be applied to lights to change their effect on the scene. These modifiers can be used or not depending on the needs of the scene. Some modifiers work only with certain types of instruments, and most instruments can have multiple modifiers.

Shadows

Shadows are the most simple or common modifier for lights in computer images. In the real world, all lights cast shadows no matter how faint. As a digital cinematographer you are faced with a slightly more complex situation. As a default, lights in the computer do not cast shadows. This can be a great boon because it means that you don't have to spend a lot of time tweaking your lighting setup so that the shadows don't fall in the wrong places. It also means that you need to decide which lights need to cast shadows. Most of the time you want the key light and any other obvious light to cast shadows because this looks more believable to the viewer. Lights that do not cast shadows look odd when they are obvious because it is a phenomenon we never see in the real world.

Although not explicitly stated, the key, back, and set lights in the last two sample scenes were in fact casting shadows. In the second scene (Figure 2.6), you can see the shadow of the chair on the back wall.

Negative Lights

A negative light is an odd but useful creation unique to the world of digital cinematography. In the real world all lights are positive and additive. That means that each new light introduced adds to the overall amount of light in a scene. In the digital world you have the advantage of using negative, subtractive lights. Negative lights actually decrease the amount of illumination in the area they affect. The ability to take light away from specific areas in a scene greatly increases the power of the cinematographer to sculpt with light.

TIP: Sometimes in a scene, especially one lit with very diffuse light, you don't want hard shadows. Avoiding them can be partly accomplished by adjusting the parameters of the shadow modifiers. When that is not effective, a great cheat is to use negative lights. By using negative light to take away a portion of the light in an area, you can create the effect of a very soft, nonspecific shadow like one you might get on an overcast day.

Projector Lights

Projector lights shine an image through the instrument as if it were a slide or movie projector. By assigning a bitmap to the light, you modify the color and intensity to correspond with the bitmap. This modifier is limited to spotlights because they have a specific area of effect (inside the cone). Either still or animated images can be used. You should not limit yourself to using projector lights only when you are recreating a movie theater. A projected bitmap can be used to add shadows of things that are not onscreen (and are not really there at all) such as a light that appears to be coming through the leaves of a tree or a stained-glass window.

TIP: Projected bitmaps can also be used to break up the regularity of a light. In the real world the combination of atmosphere and complex surfaces means that the light on an object rarely looks even. In the computer world you must work to achieve that slightly dirty, organic look. Projecting a bitmap that is just some random gray variations can help greatly in achieving this effect.

Attenuation

All types of instruments can be attenuated. Attenuation causes the intensity of the light to fall off as it gets further away from the instrument. This is an important modifier for two reasons: first, in trying to get your lighting to look naturalistic, it is important to have light fall off in the distance as it does in the real world because of atmosphere; second, it allows you to have excellent control over the area actually affected by any given light. An added benefit is that attenuated lights often render faster because there is less calculation involved since there is less affected area.

The range of attenuation is usually set by defining two radii around the light. This works the same as the cone of a spotlight does. The first radius defines the area in which the light is at full intensity; the second defines the area in which it diminishes from full to zero intensity.

Exclusion

Another modifier that is unique to computer-generated lighting is the ability to exclude specific objects from a light. By specifying an object you can make it so that any given light simply does not cast any illumination on that object. This is an amazing tool because it allows you to have lights for very specific purposes without having to cope with how they affect other objects in the scene. It also means that a light can be positioned to affect an object without regard to what other objects are in the way, because the ones in the way can be excluded. It is important to be careful with the use of exclusion so that you don't create situations where the light looks artificial because it does not affect the area around an object.

The settings for exclusion are a simple yes or no. Sometimes it is possible to separate exclusion of illumination from exclusion of shadow so that an object might be illuminated by a given light but not cast a shadow from it. As with attenuation, exclusion can also speed rendering.

Take a Look

With this example you are introduced to tools unique to digital cinematography. The use of new lighting positions for highly specific effects becomes part of the equation. Negative lights, projection lights, and attenuation introduce some of the elements of digital cinematography that are very different from photography in the real world. This example will show the basic principles involved in the effective use of tools that do not work according to the laws of the real world and may not be intuitive in their use.

Moving from the realm of the quaint restaurant to the fashionable locale of the discotheque, Figure 2.12, creates some new lighting challenges for you. Woodrow is still lit with a basic key and fill setup but the atmosphere of the dance floor needs some special attention to create the appropriate look. An effect light has been introduced in this scene to create the disco ball lighting. Negative lights have been added as well to create the dark pools under the tables.

Camera

As in the previous two setups, the camera here is standard vanilla— no fancy angles or effects. This camera is slightly above the subject.

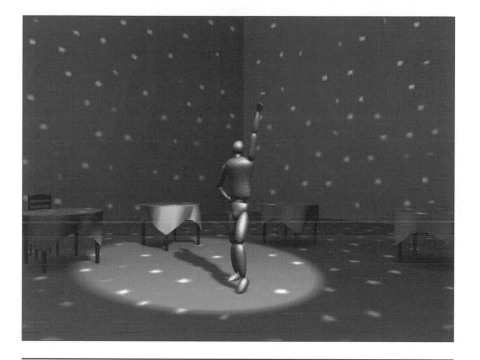

FIGURE 2.12

Key Light

Woodrow's key light (Figure 2.13) is very straightforward. For the key in this scene, there is a spotlight creating a spot of light around the subject. The implied source for this is a real spotlight, so the edges of the falloff area have been left very sharp. In keeping with the source for the light, the instrument has been placed up above Woodrow. The position is close to the same direction of the camera but offset a little. The light illuminates most of the front of Woodrow that the camera can see. The offset guarantees the dark edge away from the camera.

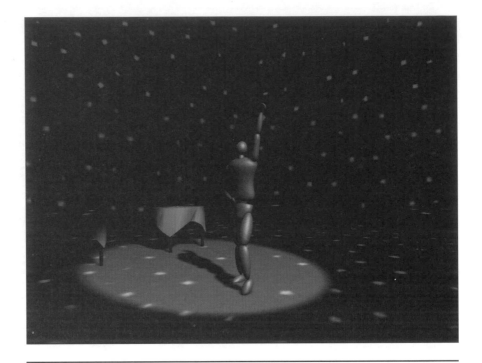

FIGURE 2.13

Fill Light

This scene's fill light (Figure 2.14), which is also acting as a set light, is a low-intensity omni light bringing the areas unlit by other instruments up from black to a dark gray. The light from this instrument is very flat, creating only minimal tonal variation on the surfaces in the scene. The flatness that is due to the use of an omni light as fill and set lights sometimes causes some visual problems. Because the omni light casts no shadows, there can be an evenness to the distribution of light that does not accurately reflect the way light behaves in the real world. Most of the time this inaccuracy is not apparent enough to cause any noticeable visual anomalies. Some cases, however, expose this problem in such a fashion that it is necessary to correct it. In this scene the key light affects only a small portion of

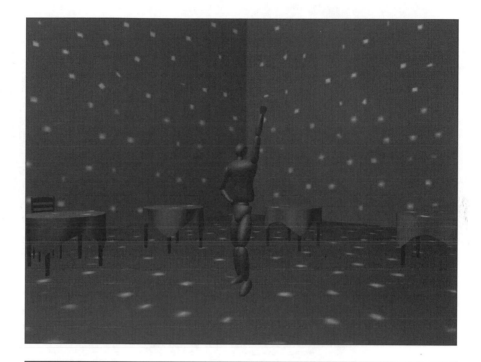

FIGURE 2.14

the final image. The fill light illuminates large parts of the scene without the counterpoint of the key light. The flat, even lighting of the fill light, lacking shadows, can lead to objects looking unconnected to one another. The tables do not look fully integrated in the scene because the floor under the table is lit evenly with the floor as a whole. In the real world, even when very diffuse lighting is creating the illumination, a large object like the table blocks light from certain directions. The blocking of some of the light creates tonal differences between areas that are and are not receiving light from a certain direction. One solution to this problem is to use shadow-casting lights, but that is not effective if the lighting is intended to be diffuse. A good way to approximate the tonal variation created by partially blocked light sources is to use negative lights to subtract light in the appropriate places.

Negative Lights

In this scene (Figure 2.15), the negative lights are positioned to subtract illumination from the floor under the tables. The light from the fill/set light creates too flat a pattern of illumination, lending an artificial look to the image. By subtracting light from under the tables, the illusion is created that light is acting in a manner consistent with the real world. A weight and connectedness is imparted to the tables because they become more realistically integrated into the scene.

The negative lights used here are spots. Shadow casting is turned off, and all the objects in the scene except the floor are excluded. There is one spot for each table, positioned directly above. The falloff

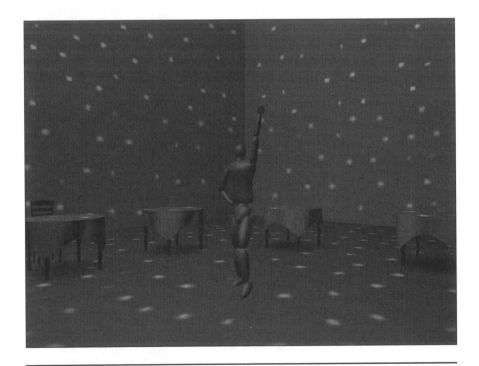

FIGURE 2.15

for the light is just larger than the table top, and the hotspot is about half the size.

In Figure 2.15, Woodrow looks rather disconnected, lacking any falloff of light intensity in the area where his feet touch the floor. If there were no other lights in the scene, it would be necessary to add negative lights for his feet as well. However, once the key light is turned on, Woodrow has a very distinct shadow that creates that connection.

Effect Lights

When trying to simulate real-world lighting effects on the computer, it is often necessary to cheat. There is no practical way to create a disco ball that will actually reflect spots of light in a spherical pattern. Instead of a real reflective mirror ball, the lighting effect has been simulated by a spotlight with a projector map (Figure 2.16). Actually, several overlapping spots, each with the same map, have been used. The map is black with a few white squares on it. The projector map works like a gobo, a mask added to theater lights to create shadow patterns, or filter for the light source. The black areas do not transmit any light; the white areas allow the light to pass. The spotlights used are rectangular. That means that instead of a circular hotspot and falloff like a normal spotlight has, the hotspot and falloff are rectangular as in a slide projector. You do not need to use a rectangular spot with a projection map, but it often makes sense because the maps are rectangular.

FIGURE 2.16

Schematics

The schematics for this setup are a bit harder to decipher than the previous ones because there are many more lights in the scene. If you focus on each light first in the rendered images and then in the side (Figure 2.17) and top (Figure 2.18) schematics, you should be able to grasp the relationships between the different lights. In particular in this scene, look at how the negative lights that create the dark areas under the tables are actually positioned high above the table tops. The table tops are simply excluded from those lights.

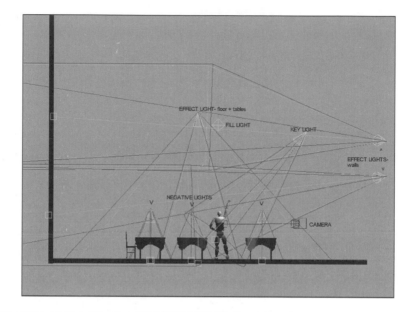

FIGURE 2.17

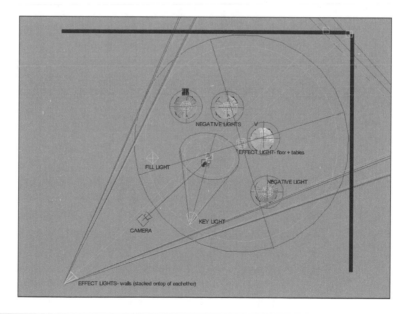

FIGURE 2.18

PLAYTIME

Explore the concepts presented in the third example. See what happens when you play with all the lighting modifiers.

- Play with shadow casting. See what happens as you adjust the shadow parameters.

- Experiment with different areas of attenuation. Try creating bright lights with very rapid falloff.

- Try using the exclusion feature. Create a naturalistic lighting setup in which you use the exclude feature to have lights affect only a single object in the scene. Now try using the same feature to create very stylized lighting, like a heavenly glow that affects only one object.

- See what you can do with a projector light. Try projecting an image over your scene. Use a "dirty" map to create some subtle variation in your lighting. Use a projected bitmap to create the impression that light is streaming in through an offscreen window.

Wrap-Up

This chapter introduced some of the basic tools of the digital cinematographer. Through the examples you learned about lighting positions and instruments and how to coordinate them into a unified whole. You also learned how to use specific lights within the context of a real production situation. You examined how to use a key light to illuminate your subject and how to use the back light to emphasize him. Lighting the set and the creation of effects were explored. With the introduction of negative and projector lights, you saw some of the unique tools of digital cinematography. All this was combined

with some basic aesthetic principles that are the ultimate driving force behind how you decide to use the tools at your disposal.

Without lights, cinematography is just snapping photos with your old insta-matic. Lighting brings a richness of image to your material and allows you to use the visuals as another layer in the artistic cake. There are many uses of light that have not yet been touched on in this book. As the chapters progress to more specific subjects, we will examine more lighting positions and effects. We will continue to learn more about the tools already introduced as well.

While lights are a great part of the cinematographer's arsenal, they are by no means all of it. To continue the exploration of the craft of the cinematographer we need to look at the other critical tool—the camera. Read on and find out how to use the camera to reveal the images you are creating.

3

Introduction to the Camera

In the last chapter you were introduced to some of the basic lighting tools you will use as a digital cinematographer. Lights are only one tool set, however; equally important is the camera. If lights help you compose the scene in terms of what you see—what is revealed—then the camera composition determines how it is seen. The camera imparts much of the attitude in an image. What you do with the camera, where you place it and how you position it, can infuse a scene with a distinct feel, an attitude. A camera that isn't parallel to the ground gives the scene a feel of stilted reality. Remember the old *Batman* TV show? Especially in the fight scenes, the camera would always be tilted one way or another to give it that comic-book feel. A camera placed low to the ground can make a character seem gigantic. There are lots of variables in what you do with the camera; each adds another layer to the look and feel of the scene.

This chapter will focus on the basic camera tools of lens, position, composition, and depth of field. These are by no means all the possible variations for the camera; some others will be covered in later chapters. The scope of atmospheres that can be created with these simple tools is immense and will enrich your images.

As with the lighting covered in the last chapter, digital cameras (that is, computer-generated cameras, not ones that record digitally) are very similar to the cameras used by analog cinematographers to capture silver-nitrate–based images of real objects. The paradigm of the camera has had a strong influence in computer-generated imagery, and so you will find many familiar settings and functions. Computer cameras can also break the rules of physics and the real world and do things that analog cinematographers only dream of (though without some knowledge and forethought, those dreams are often nightmares).

Bad camera work ruins good CGI animation more than any other element. Too many artists have no experience with composing in three dimensions and as a result they place and move cameras in ways that detract from, rather than add to, their scenes. Composing scenes in computer-based 3D space is no different from composing them in physical 3D space. It is critical to understand how the position and movement of the camera affect the viewer and to plan a strategy of use based on this understanding. Movement is a beast unto itself and will be covered in a later chapter. For now let's look at the tools you have to work with in using the camera.

Lenses

With an analog camera the field of view (FOV) is a product of the lens on the camera. The computer mimics this by having a lens-angle

setting that is directly related to the FOV—adjusting either changes both. Lenses with large FOVs are referred to as wide-angle or wide. When the FOV is small, the lens is referred to as long. The angle of the lens affects how much of a space is seen through the lens, but it also affects how the objects in that space appear. The longer the angle of a lens—the smaller the FOV—the more compressed distance becomes. The wider the lens, the more distorted objects appear. You have probably seen a fisheye lens in some bad horror movie that distorts everything into a circle in the middle of the screen. A fisheye lens is the extreme of a wide-angle lens. Less extreme lens angles distort less but distort nonetheless.

JARGON: *Field of View (FOV)* is the term that refers to how much of what is in front of the camera is seen through the lens. It is easiest to think of the FOV as a cone that extends from the lens of the camera. If the lens is the center of a circle, then the number of degrees in the FOV refers to the number of degrees in the segment of that circle that is intersected by the cone. The wider the field of view, the broader the base of the cone. The cone for a 10-degree FOV would be long and thin, whereas the cone for a 90-degree FOV would be very broad.

While the field of view is measured in degrees, the lens is measured in millimeters. This is because with a traditional camera it is the distance between the front of the lens and the film inside the camera that determines the FOV. Lens length is inversely proportional to field of view—the longer the length of the lens, the smaller the FOV. Hence a 100mm lens has a much smaller FOV than a 10mm lens has. This relationship is important to remember because many animation packages let you set either the FOV or the lens length, and increasing the numerical value in each of these respectively has the opposite effect.

In choosing a lens for the camera in a scene, we digital cinematographers are much freer than our analog counterparts. Often in the real world, the choice of lens is dictated by the filming conditions. If the scene is being shot on location in an interior, the cinematographer

is often forced to use a wide-angle lens in order to take in enough of the scene. Conversely, wildlife photographers are often forced to use very long lenses so that they can remain far enough away from their subject to be unobtrusive. Without the constraints of physical limitations or self-conscious subjects, choice of lens for computer-generated images becomes almost entirely aesthetic. Thus, it is very important to understand the different visual effects produced by different lenses and the connotations of those effects in the language of film or visual media.

Standard Lenses

In 35mm photography, which is the model used by most animation packages, the default, standard lens is 50mm. This is neither long nor wide, but sits right in the middle. The human eye actually has a slightly wider FOV than this, approximately a 35mm or 40mm lens, but 50mm is what we are used to seeing as normal when watching movies or looking at photographs. The FOV for a 50mm lens is about 40 degrees.

In aesthetic terms, 50mm is the vanilla lens. It does not have much inherent visual impact, which can be an asset when you are trying to create a naturalistic style. When the goal is to present what is in front of the camera as objectively as possible, this standard lens can be very effective. While you often want to imbue the scene with some attitude from the camera, at times the scene needs to speak for itself. The choice might be made to use a standard lens because the subject matter is very naturalistic and you want the camera to conform to this style. On the other hand, your subject matter might be so stylized that you choose a vanilla lens to balance the effect.

 TIP: Sometimes it is very effective to use a standard lens in most of the shots in a sequence to emphasize a wide or long lens used in a few shots. The visual impact of a stylized shot can be heightened if it is within the context of naturalistic images. This technique might be used to impart information about a specific character. If the hero of the scene is shot with a standard lens, making her look normal, and the villain is shot with a wide-angle lens to create a distorted feel, you enhance the distinction between the two by the contrast in how you show them.

Long Lenses

Long lenses have a very narrow field of view and can enlarge something that is far away. In the real world, cinematographers often use long lenses for shots that are not possible from close up. Long lenses are used extensively in wildlife photography where the subject isn't always willing. For the same reason news photographers often use long lenses to capture images they can't get too close to. As a digital cinematographer you don't have to worry about the physical limitations of where you can put the camera. You can, quite literally, put it anywhere you want. Why use long lenses if you can put the camera right up to the subject? Because along with allowing the photographer to be distant from his subject, long lenses also create a particular visual or aesthetic effect.

The narrower the field of view, the less emphasized the perspective is in the image. The narrowest possible FOV is an orthographic or parallel view in which objects do not appear smaller as they get further away. This is not possible with a real lens, but can be done in the computer by rendering an orthographic viewport that has no perspective. Mostly, though, even when you want very little perspective in a shot, you still want some because your viewers are not used to seeing things without perspective. A side effect of decreased perspective is that the apparent distance between objects as they recede from the camera is greatly reduced. A long lens can make

objects that are many feet apart appear to be right next to each other. This side effect is due to the fact that one of the ways we judge distance is by size differential. Assuming we know the approximate sizes of two objects, we use the difference in their apparent size to judge the distance between them. As a cinematographer you can find ways to use this compression of distance to enhance the look or emotion of your image.

A classic example of using the compression of distance for artistic effect was taught in every filmmaking class I ever attended. If you want to create a shot of someone running but going nowhere, you shoot it with a very long lens. The effect of the narrow FOV is that even though the actor may cover a lot of distance his size on screen changes very little; hence, you imbue the scene with the feeling that he is going nowhere even though the viewer can see him running.

TIP: Another use of long lenses is imitating traditional cinematography to create a sense of reality or validity in your shot. If you are working on a shot of an animal, for instance, you might want to use a long lens to imitate real wildlife photography. If you are creating a documentary feel, you might want to imitate news photography. Aerial dogfights are a great example of when using a long lens to imitate reality adds greatly to the veracity of your shot. Viewers are used to seeing airplanes and especially air combat shot from a great distance, through a very long lens. This is because in the real world it's pretty tough to get right up next to an airplane engaged in combat, even when staged. If, as a digital cinematographer, you shoot an air combat scene with standard or wide lenses, from near the airplane, the viewer may not find the scene as believable.

People are used to certain visual conventions created by both the freedoms and the limitations of regular photography. If you are trying to imbue your CGI work with a sense of reality, it is important to use these conventions to your advantage. It may mean putting physical limitations on your shots even though you are not actually restricted to those rules.

Wide-Angle Lenses

You might think that the opposite of a long lens is a short lens. In fact, short lenses are referred to as wide or wide-angle because they have a wide field of view. Wide-angle lenses see a lot of what's in front of them. Where you use a long lens to photograph something that is far away and seems small without magnification, you use a wide lens to take in something that is all around you. A wide FOV allows you to capture more of the scene in a single shot.

Like the long lens, wide-angle lenses are sometimes used out of necessity in the real world. If the space in which you are filming a scene is small, you might need to use a wide lens just to get enough of it onscreen. Again, as a digital cinematographer you are not limited by the reality of the space you are working in. You will find, however, that wide-angle lenses also impart a certain feel or look to a shot that you can use to enhance the effect of the image.

Long lenses compress the space between objects as they recede from the camera, whereas wide lenses expand that space. The result of having a wide field of view is that the effect of perspective is amplified. The rate at which objects appear to get smaller as they recede from the camera is accelerated. With a long lens, objects that are far apart may appear close together, whereas with a wide lens the converse is true. Objects that are in fact not very far apart can appear to be distant from each other. This is true even of parts of a continuous object.

One of the most visible uses of wide-angle lenses is in distorting faces. Think back to those bad 1970s psychological thrillers where the heroine goes crazy. You know she has lost her sanity because suddenly everybody's face is distorted. Their nose is as big as the rest of their head, their face seems to warp as they turn their head, the hand coming at the camera obscures the whole scene behind it. This effect is due to the fact that a very wide lens expands distance

to such a point that even the distance between the tip of the nose and the ears can seem large. The strangeness of the effect comes from the difficulty our brains have in reconciling the seemingly contradictory information. The relative size differences tell our brain that the distance is great, and yet we are looking at a human face that we know to be a certain size (within very small tolerances all faces are about the same size.) The conflict between what we see and how we know the world to be creates a feeling of reality out of balance, which is why this effect is used so often to imply madness.

Wide-angle lenses also create a warping of space that is most notice-able at the edges of the image. As mentioned earlier, the most extreme wide-angle lens is a fisheye that actually distorts the image into a circle at the center of the screen. CGI lenses do not create that circle effect, but they can distort the image just as severely. If you move a wide-angle lens through a scene, you get a sort of warp effect at the edges, as if space were bending around the camera. In a sense, that is what a wide lens does—it bends space so that more of it will fit in the field of view.

Compare and Contrast

To get a sense of the different effects of FOV, look at the sample images. The scene is Woodrow, our hero from the previous chapter, worshipping at the Temple of the Great Teapot. The shots were composed to keep the figure of Woodrow the same size in each image, emphasizing the difference in field of view with each lens.

The shot done with a standard lens (Figure 3.1) shows Woodrow kneeling in front of the teapot shrine, which is some distance in front of him. Some sky is visible, and a row of columns runs down the sides of the path leading to the temple.

FIGURE 3.1

The long lens (Figure 3.2) changes the look of the shot dramatically. The setup of the scene has not changed at all. The only changes are the length of the lens and the position of the camera. In order to keep Woodrow the same relative size in the scene when using a longer lens, it was necessary to move the camera back quite a way. This shot really shows the spatial compression effect of a long lens. The columns that appear spaced apart when seen through the standard lens now appear to be right next to each other. We lose not only the sky in this shot, but the top of the shrine as well. In this shot Woodrow seems to be almost all the way to the wall of the temple.

Now compare the image created with a wide-angle lens (Figure 3.3) to the others. Instead of the spatial compression of the long lens, here we have spatial expansion. The temple appears to be far in the distance. We see a lot of the sky, and the columns seem to be distantly

FIGURE 3.2

FIGURE 3.3

spaced. The warping distortion is also visible in the columns, which appear to be oval rather than round.

These images show the extremes of what different FOV settings can do to an image, but there are an infinite number of settings between these extremes. Using the lens of the camera for aesthetic effect does not mean that you need to be as extreme as these examples. The same principles can be applied in a more subtle, less extreme fashion to achieve equally powerful effects. A little distortion can go a long way toward imparting a sense of atmosphere to your scene.

PLAYTIME

There is no substitute for experience. The easiest way to understand the concepts presented in this book is to try them out for yourself. In the preceding section we examined the effect of using different lenses or field of view. Play with that concept by rephotographing (rerendering) one scene through a number of different lenses. Make sure the scene has both foreground and background elements so you can see the effect of the perspective changes as you switch lenses. You might want to try some of the following effects:

- Shoot the subject with a very long lens. Isolate him completely from the background.

- Try using a wide lens to take in all of the background.

- Place an extremely wide lens right next to the subject. Move it around and look at how it distorts the image.

- Try positioning the subject's hand outstretched in front of his face (or, in the case of nonhumanoid subjects, whatever appendage is handy). Position the camera so that the hand is between it and the face. See what happens as you change the FOV. Move the camera around to adjust the composition for the different lenses.

Camera Placement

Crafting a powerful image means putting the camera in the right place. While the field of view can affect the mood of the image, nothing is as important as camera placement. Where you choose to put the camera—where you place the audience point of view—lets the viewer know how to look at the subject. Is the camera near or far? Is it above or below? Straight or tilted? Each of these possibilities gives the scene a different flavor. Conventions have evolved regarding what placing the camera one way or another means, and we will examine some of these. However, the simple reality is that you must find places to put the camera that infuse the scene with life. The camera is the other character in the scene, the eye of the voyeur. How it sees the scene is intertwined with the role of the viewer. If the placement of the camera is in harmony with the emotional content of the scene, the viewer gets an undiluted message. If the camera fails to support the mood of the scene, the message may be muddied.

We are going to examine some of the basics of camera position and what emotional message positioning sends. Images are not a static medium; you don't simply put the subject in front of the camera and shoot. The art of images is to capture an emotion within the context of presenting the visual information of your story. The art of placing the camera is creating the point of view that communicates the emotional content. There are some simple ways of using the camera to let the audience know that someone or something is powerful or powerless, on the level or on the make. There are as many variations on these basic concepts as there are artists, and yet there emerge from all of that work some simple rules.

Camera Height

Two important pieces of information can be communicated or at least implied through the height of the camera. The first is the

observer's status within the context of the scene. As the camera is the viewpoint of the audience, it sets the scope of the viewer's knowledge of what is going on. If the camera is placed high above the scene, it places the viewer above the action, making him an uninvolved observer. When you want the viewer to feel as if he knows more about what's going on than the subject of the scene does, placing the camera above the scene and looking down reinforces this feeling. It is like watching a riot from the tenth floor of a building—you can see what's going on but you are not in the fray.

If you want to put the viewer right in the middle of our metaphorical riot, put the camera right on the same level as the action. Placing the camera in the thick of things gives the audience less overall scope of the action. They don't really know any more about what's going on than the participants in the scene do. The loss of overall scope is accompanied by an increase in intimate detail. With the camera placed above the action, the viewer is likely to feel detached from the action; with it right there an emotional intimacy is created. The audience can feel almost as if they are participating in what is occurring.

The relative strength of a character within the scene can also be intimated by the height of the camera. This is related to the viewpoint of the audience insofar as it has to do with how they observe the character. When you are observing the character from above, he seems to have less power. In brute psychological terms you are looking down on the character. Shot from below, the character is filled with strength because you are looking up to him. This gimmick can be especially useful in scenes with more than one character. Camera height can be used to establish a pecking order within the scene. In a fight sequence, for instance, camera placement can be used to help the viewer understand who is winning. The character viewed from above has less power than the one viewed from below, so it is easy to understand that the winner is the one you are looking up at. This method can also be used to add complexity to the scene. If the idea of the scene is to show that the character who is losing the fight, in the physical sense, is actually gaining the moral (or psycho-

logical) victory, you might choose to use camera height to counter-point the action. Look up at the loser, and you set the stage to show the audience that he is actually the winner.

The same scene of Woodrow has been shot from five different camera heights, ranging from extremely low to extremely high, to illustrate the different feel each creates. The first is a straight-on shot (Figure 3.4). The camera was placed at about five feet, eight inches off the ground to approximate the standing viewpoint of an average man. This shot portrays Woodrow as an equal, just a regular guy walking away from the temple.

The high camera angle (Figure 3.5) still creates the feeling that Woodrow is a normal Joe, but it gives the viewer a sense of being above it all. This points out how important the degree of extremity is; looking slightly down on the subject does not detract from his power as much as it adds to the power of the audience.

Place the camera extremely high (Figure 3.6), and you do take power away from the character. Looked down on from way above, Woo-drow has a bit of an ant-like quality. He becomes a small figure in a big world, walking away from the temple humbled. Even though there is very little in this shot aside from Woodrow's figure, he still looks insignificant. The vantage point of the viewer is elevated as well. If people are only ants, the audience is watching from the point of view of someone as far above people as people are above ants.

In contrast, place the camera below the subject (Figure 3.7), and you impart power to him. Seen from below Woodrow is standing tall, slightly bigger than life. This is the classic hero shot. The camera is placed just a little below the subject to give him heroic stature, to make him just a little bigger than life. This simple shot of a figure walking toward the camera imparts a feeling of accomplishment or victory because we are looking up at him.

Put the camera all the way down on the ground (Figure 3.8), and Woodrow becomes a giant. We are seeing him from the point of view of an ant. This makes him seem very powerful, but it also makes the

FIGURE 3.4

FIGURE 3.5

FIGURE 3.6

FIGURE 3.7

viewer feel less powerful. Whereas the camera placed slightly below him made Woodrow look heroic, placing it so far down makes him somewhat scary. He ceases to be a hero from this vantage point because he seems so much more powerful than the audience that he is intimidating.

PLAYTIME

The height of the camera can change the way the viewer looks at the subject. Use a scene of your own to explore this idea. Set up a scene with one or two characters, and try using the height of the camera to establish their relative importance in the scene. Play with both extreme and subtle differences, and see if you can find the points at which the camera changes the viewer's perception of the characters. Try some of the following:

FIGURE 3.8

- See if you can make the same figure look heroic, scary, and defeated just by changing the height of the camera.

- Try putting together a simple sequence with two characters, using the camera to establish one as the hero and the other as the heavy.

- Switch the character roles from heavy to hero and vice versa. Do this only by changing camera positions.

Camera Angle

Camera angle refers to where the camera is placed in relation to the action of the scene. It should not be confused with lens angle, which refers to the field of view through the lens of the camera. If you think of the action in a scene as being contained within a circle, the camera angle is where on that circle you place the point of view. In setting up your camera for a shoot, you don't think about camera angle as separate from camera height or roll (covered in the next section)—it is all placement. However, for defining the different aspects of placing the camera, it is easiest to look at them separately. In the examples that follow, there are differences not only in camera angle but in height as well. Try to separate the different elements as you look at the images.

Placing your camera on the left side of the action as opposed to the right can have a big effect on what the audience sees. It changes what appears in the background and who is on which side of the screen (assuming you have more than one character), greatly affecting the scene's overall composition. If you are editing together different shots, as with a movie, it can be critical in making a cut work. It is difficult to create generalized rules for camera angle because it is very dependent on the content of the image. Look at the same scene

of Woodrow and his evil twin in action shot from the left and then the right. See what differences occur in the image.

We have two shots from "Heroic Ninja Artist Mannequins." The scene is the big kung fu standoff between Woodrow (in white) and his evil twin (in black). The shots are the same action sequence, but are photographed from opposite sides of the action. Each shot has desirable qualities. First is the image from the right side (Figure 3.9). The biggest strength of this angle is that it creates a feeling of depth. The action is contained between the pillar in the foreground and the pillar in the background. By having strong elements in front of and behind the characters, a sense of depth and 3D space is created. Even though the medium we are working in creates images from three-dimensional models, the images are presented on a two-dimensional screen (or page or tee shirt or what have you), and it is important to

FIGURE 3.9

keep that sense of the action taking place within a space with depth. Without some visual cues to the dimensionality of the scene, you may end up with images that look like they are from an old side-scrolling video game.

What this shot lacks is a sense of location. There is no background showing, and the pillars look generic. You may not need a shot that gives location information; it depends on what comes before and after. If there are other shots in the sequence that establish where this is taking place, the only relevance for this shot may be in depicting the action.

If there are no other shots that establish the location, you might want to look at the shot from the left (Figure 3.10). This shot does not do as good a job of creating dimensionality as the one from the right does, but it shows the location very effectively. In the background you can see the Temple of the Great Teapot. This piece of information may cue the viewer to the importance of this fight. Woodrow and his evil twin are not just sparring; they are engaging in a battle over the fate of the holy temple (admittedly, for the shot to have this effect there would have to be some setup in the script).

Each of these shots can impart information to the audience, and which one will be appropriate depends on what information you need to give the audience at that moment. It may also depend on what shots come immediately before and after. The choice of angle is often dictated by the needs of the editor. As you plan the shots for a sequence, it is important to think about how they will fit together in the final edit.

 PLAYTIME

There are no hard and fast (or even soft and slow) rules about where to place your camera in a scene, but there are many things to think about as you compose a shot.

FIGURE 3.10

- What is behind the character? Does that add another level of information to the scene?

- Is there a sense of depth in the shot, or does it come across as flat?

- If there is more than one character, do you see the face of the one you are focusing on?

- Will the shot fit with the other shots in the sequence?

Camera Roll

Another variable of composition is camera roll. To adjust the height or angle of the camera in the scene, you change its physical location. To adjust the roll you only change its orientation to the ground plane. The "vanilla" shot is set up with the camera parallel to the ground. Sometimes you want to roll the camera so that it is no longer parallel. Skewing the image from the normal point of view can add another layer of subtext to the composition. By changing the roll of the camera, you can change the dynamics in the scene. The camera roll can give a shot a feeling of skewed reality, or it can reveal the situation of a character. The old *Batman* TV show is an excellent, if not subtle, example of skewed reality. The camera was almost never parallel to the ground, creating a comic-book aesthetic. The camera roll in combination with placement created the show's wacky, campy look. Many action movies make extensive use of camera roll as well.

Rolling the camera does not need to be so all-pervasive. A little bit of roll can add power and attitude to a shot. A simple walk down the street can be turned into a monumental uphill battle just by changing the roll of the camera to put the character lower on the screen than his goal.

The frequency and extremity of the camera roll should be dictated by the subject matter. In a naturalistic, dramatic scene, you want to keep it subtle. In a stylized action scene, you might make extensive use of it. Regardless of how much you actually use roll you should always be aware of its potential as a tool.

To examine the camera roll in action, we will return to the epic battle between Woodrow and his evil twin on the grounds of the Temple of the Great Teapot. This shot makes full use of rolling the camera. The subject is a rather over-the-top kung fu story. The sets and costumes (or in this case the actual phenotype of the actors) are stylized. The roll adds to the stylized, comic-book feel of the image.

It also lets us inform the audience of the situations of the characters. Placing one character higher in the frame creates a sense that he is "on top."

The clockwise roll (Figure 3.11) places Woodrow, in white, at the top of the frame. He is literally above his opponent, and this creates a sense that he has the upper hand in the conflict. The kick of the evil twin looks much more difficult than if the camera were parallel to the ground, because he has to deal with going uphill. The roll of the camera also adds to the dynamic quality of the scene. Kung fu is all about flipping and rolling and turning (at least in the movies). By doing the same things with the camera that the characters are doing, you emphasize that motion.

FIGURE 3.11

The counterclockwise roll (Figure 3.12) puts the evil twin in the driver's seat. His kick is now aided by the fact that he is going downhill. The shot also comments on the potential outcome of his victory. The Great Teapot, symbolic of the struggle, is so askew that it looks as if it could topple off its stand. This is foreshadowing the result of the evil twin's victory.

PLAYTIME

The roll of the camera can be a tool in adding subtext to a scene. In the example of the kung fu battle, both the roll and the message were less than subtle. You can use camera roll to create similar but much more understated effects. Try experimenting with a simple portrait shot, one character, and some simple background.

FIGURE 3.12

- Roll the camera first clockwise and then counterclockwise. Look at how the background and asymmetry in the character affect the roll in each direction.

- Experiment with the severity of the roll. Note the difference between a 5-degree and a 40-degree roll.

- Try out the roll at different distances from the character. How does the effect change when you see the whole body or just the head?

- Combine roll with angle and placement, trying out different combinations of settings.

- Add lens angle to the equation. How does the effect of a roll differ with a wide lens versus a long lens?

Depth of Field

Depth of field is a phenomenon that occurs when you use real lenses to capture images on film. Put simply, depth of field (DOF) is a measurement of how large an area of clear focus you have in front of the camera. When you look at a photograph, especially one taken in low light, you will see that some of what you see is in focus (hopefully) and some isn't. What is in focus is determined by where you set your point of focus—this is what you are doing when you focus the camera on a specific object. How much in front and behind the point of focus is in focus is determined by the DOF. In the real world, DOF is governed by how much light is available, what lens you are using, and what kind of film you are using. None of this matters when you are working on a computer. Depth of field does not occur naturally on the computer. In order to have a varying amount of focus in your image, you must tell the computer to do it. Different animation packages have different methods for this. Some

packages create simulated lenses and atmospheres, actually mimicking nature. Other packages let you apply it as a post-rendered effect. Some support it only as an additional plug-in.

"Why," you might ask, "should I go to the trouble of getting an external plug-in to simulate a technological side effect of photography?" The answer is (drum roll, please) because we're used to it. Depth of field has become an integral part of film vocabulary. Photographers have no way to get around DOF, so they have incorporated it into the language of film. But in rendering images on the computer, it is easy to have infinite depth of field. You can create images that lose no sharpness regardless of an object's distance from the camera. In the real world you cannot do this—there is always some loss of focus within an image. The reason to add this "flaw" to your CG imagery is that it gives it a feel of authenticity. Viewers may not be able to tell you the difference between an image that has depth of field and one that does not, but they will tell you that the one with it looks more real. It looks more like a photograph.

How to use depth of field is an individual choice. Many filmmakers have that choice made for them by real-world constraints ("Sorry, Mr. DeMille, we don't have the budget for that many lights"). As a digital cinematographer you have only aesthetic choices to make. You can have anything from zero to infinite depth of field, so you need to decide what works best from an artistic point of view. If you look at *Citizen Kane* you will see that Greg Toland, the cinematographer (who shares the opening credit with Orson Welles), went to great pains to get great depth of field. At the time this was incredibly deep focus for a film shot indoors, but Toland and Welles felt that very deep focus was important for the story. If you watch MTV for five minutes, you will see videos where the DOF is as little as a few inches. The singer's mouth may be in focus while the rest of the face fuzzies out. In this case the director and cinematographer decided that they wanted very shallow focus. Both choices are right for the respective productions.

However you choose to use depth of field, there are two important decisions in setting it up. The first is how deep you want the focus. Do you want the area of focus to be five or a hundred feet deep? The second factor is the point of focus. Think of the area in focus as being a circle. It may be five or a hundred feet wide, but it is still a circle. The point of focus is the middle of that circle (with real cameras and film it's actually about two-thirds of the way back, but this is CGI). The area in focus is centered on the point you choose. It is the combination of these two factors that turns depth of field into an important creative tool. You can use the varying sharpness within an image to focus the viewer's attention (pardon the pun).

The first shot of the Blob Squad (Figure 3.13) has an infinite depth of field, which is how images are automatically generated by the computer, you can see that there is no loss of sharpness. This can be an effective way to present an image. However, just because you have the option to use DOF doesn't mean you always should. Space scenes often work well without any DOF. If your project is a cartoon, you may find DOF unneeded.

Sometimes you will want to use DOF. The second shot of the squad (actually the same shot with DOF added) (Figure 3.14) has the members in the foreground in focus while the cat in back is out of focus. The DOF here is fairly shallow, only a few feet, focusing attention on the foreground characters. This allows you to have a third character in the scene but to keep the focus where you want it until you want that to change.

When you are ready for the third character to become an active part of the scene, you might just switch the point of focus. The third shot (Figure 3.15) has the same DOF as the second, but has switched the point of focus to the cat in back. This creates an image where the foreground elements are out of focus, which can be a very effective choice. The viewer is clued in to the fact that she should switch her focus to the cat but continue to watch the foreground action in a generalized way.

FIGURE 3.13

FIGURE 3.14

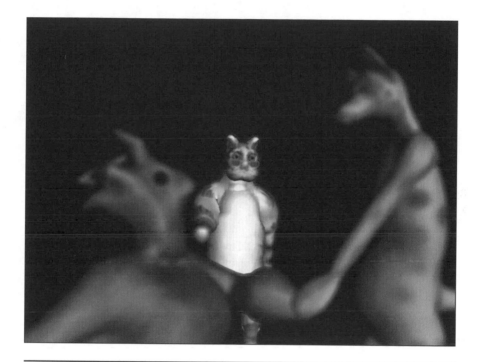

FIGURE 3.15

The final shot (Figure 3.16) is a closeup of the cat. Here the depth of field is only a few inches. The cat's eyes are the point of focus. You can see that even his glasses, only a few inches in front of his eyes, are getting a little fuzzy.

PLAYTIME

Adding depth of field to your CG imagery can make it look more authentic and can be used to focus the viewer's attention. Whether you use deep or shallow focus, regardless of where the point of focus is, this is another important tool in your bag of tricks. To develop a feel for how to use DOF most effectively in your images, you should

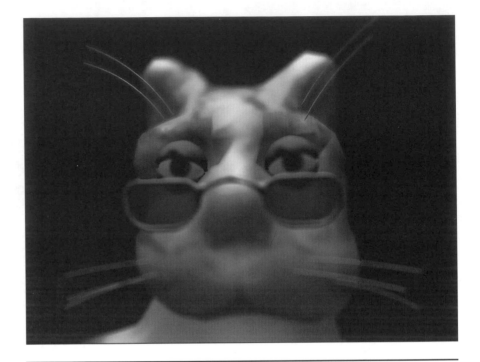

FIGURE 3.16

take some time to experiment with different settings and effects it can be used for. Set up a scene with multiple characters or subjects at different depths from the camera. Try creating several images, each using different settings for the depth of field.

- Set the point of focus on a subject in the middle of the scene (neither foreground nor background). Start with deep focus and rerender the image with decreasing depth of field.

- Set a shallow depth of field. Switch the point of focus between the different subjects in the scene.

- Reset the DOF deep enough that two characters can be in focus simultaneously. Try different pairs of characters.

Wrap-Up

In this chapter you were introduced to the various aspects of using the camera in creating your images: placing the camera within the scene to get the most emotional effect; using the height and roll of the camera to reveal aspects of a character; using different lengths of lenses and depths of field. All of these techniques affect the composition of the scene, and that's what using the camera is ultimately about. As lighting is about revealing the elements in the scene, camera work is about presenting the scene as a whole. With the basic tools under your belt, the next step is to use them to create specific looks and styles. While there are no rules that dictate what style you should use for a given subject matter, there are some conventions that fit into certain genres. In the next chapter we will look at how to use the tools you have learned thus far to create visual styles associated with different genres of film.

Film Genres

Movies have been around for over 100 years, and in that time many genres have evolved. A genre is a category of artistic composition marked by a distinctive style, form, or content. Originally the genre of a film was distinguished by content alone; however, over the past century certain visual styles have become associated with particular themes, opening the door to visual genre in film. Viewers have come to expect particular visual qualities in certain kinds of movies. Detective films are dark and gritty; comedies are bright and colorful; westerns are panoramic. Though these traditions are not found in all films of a genre, they do tend to add a context and history to the film by visually relating it to those that have come before.

As a digital cinematographer, you can use the visual style associated with a genre of film to add a specific flavor to your animation. In a two-hour feature, the creator has the luxury of time to establish a mood. Computer-generated movies rarely have such leeway. Whether a half-hour piece for broadcast or cinematics for the opening of a video game, time is usually brief. Therefore, using established visual styles associated with specific genres allows you to give the viewer a lot of information quickly. For example, a shot of a man in an old suit, sitting at a desk and reading some files gives the viewer very little information about character or theme. However, if the office is dark, lit by a single desk lamp, with cigarette smoke curling up through the light and stark shadows on the hero's face, the viewer is likely to associate the visual style with a hardcore detective movie. Assuming you are making a detective film, these additions instantly give the audience a point of reference from which to interpret the scene. Rather than a few scenes to establish the character as a rough and tough P.I., this genre-specific style acts as visual shorthand that imparts this information in the opening shot.

Unfortunately, there is no guidebook describing the visual style of a film genre. Instead, that style comes from the tradition of similar films. Films often intentionally play against the genre stereotype, and even those firmly rooted in the tradition exhibit a great breadth of visual style. You should never feel constrained by a genre but rather freed by it. Placing your film in a visual tradition doesn't limit you to the established lighting and composition; it simply allows you to convey certain aspects of mood and character by using stylistic pointers already familiar to the viewer.

In this chapter we will explore a few of the visual traditions associated with specific genres and the tools used to create those effects. Only four styles have been chosen because of space limitations, each because it strengthens the film thematically as well as visually. Look at these techniques as case studies in what can be done with cinematography, not as a complete survey of visual style.

Film Noir

Film noir is the visual style used in the classic gangster movie. Traditionally it imparts a dark mood and uses a lot of contrasting light and shadow to create a strong, graphic look. The subject matter tends to be dark and gritty, contrasting black and white—good and evil—with little gray area. The emotional tone tends to be ambiguous, presenting a world where actions are clear and succinct but their meaning is veiled in mystery. The visual style reflects the narrative by presenting images that are harsh and full of contrast, with bright highlights and deep shadows.

Usually shadow and darkness are used to separate characters from the background and to create dimensionality. Film noir often turns this concept around and uses light to accentuate the darkness. It is a visual portrayal of the thematic cynical world in which good must struggle to separate itself from evil. Darkness serves as a compositional element to create a terse visual style that reveals only the bare minimum of information, accentuating the mysterious, unknown quality of the story.

In most genres it is important to keep the face of the character in the light so that the audience can see and identify with him. Noir often uses shadow to hide the face or eyes of a character, making him dark and mysterious and leaving the audience to wonder what is going on in his head. Entire scenes may be presented in silhouette, depicting action but eliminating emotional contact with the characters. Film noir is the art of implying rather than presenting information to the viewer. The plot and mood are portrayed visually, but the specific reactions of characters are often omitted or underplayed, leaving the audience with the same uncertainties the characters are experiencing.

The stark look of film noir is often achieved with single-source lighting, a style based on the use of a single, strong light as the main source of illumination in a scene. Fill and back lights are eliminated

or used sparingly, creating a scene with strong contrast between light and dark. As with many lighting techniques the original impetus for this was probably budgetary, as simple lighting costs less and takes less time to set up. Necessity, however, has given rise to art, leading to the creation of a rich visual style with a long tradition.

Take a Look

Figure 4.1, our first look at film noir, is from "Mannequin: P.I.," a detective show starring your friend and mine, Woodrow. This image shows how you can use darkness as a compositional element. Seventy or 80 percent of the frame is pure black, yielding no visual information at all. The light areas define the shapes in the dark, outlining the silhouette. Though some amount of detail is visible in the lit areas, most noticeably the bricks of the wall outside, the light is used primarily to create simple graphic shapes. The composition of the frame is based on the shapes formed by the light and shadow rather than on details of the set or character.

Despite the lack of detail, Woodrow immediately pops forward as the focus of the scene. Framing him in the brightest area on the screen draws the viewer's eyes; their attention is then caught by the irregular outline of his silhouette. In a scene dominated by the straight lines of the window and door, Woodrow's curvy, organic outline is prominent because it is different and recognizable as a human form.

Lighting for a silhouette shot is simple. A shadow-casting spotlight placed outside and behind Woodrow, streaming into the room, creates the patches of light from the door and window. Woodrow's shadow in the doorway is cast by this light as well. A second light, in this instance an omni, illuminates the wall behind Woodrow, creating the bright background that reveals his figure in the door. No

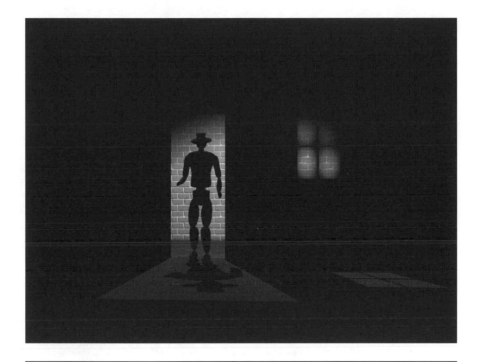

FIGURE 4.1

other lights are needed because there is no fill or back light. This is single-source lighting at its purest.

When you use single-source lighting for a scene, placement is critical. The light and shadow created by that single light define all the shapes in your composition, so if you adjust that light you change the composition of the entire scene. Often when using this lighting style, you will want to block the scene, adjusting the movement of the characters and camera based on the lighting. While you almost always design lighting and blocking simultaneously, usually the lighting is changed to fit the movement. In a heavily graphic style such as noir, the compositional impact of the lighting is great, and you often fit the movement to it.

Take a Look

Noir is not created exclusively with single-source lighting. In Figure 4.2 we are looking through a window at an office. The lighting, while still full of contrast, is not generated by a single source but by several. The light on the walls is created by a point light positioned inside the lamp. A second point light, in the center of the room, creates a bounced fill light. Shadow-casting spotlights create the light cast on the floor by the lamp and the moonlight through the window on the far side of the room.

The strong graphic element of the shot is created by the silhouette of the window in the foreground. The frame of the window creates a frame for the scene, focusing attention on the area around the desk.

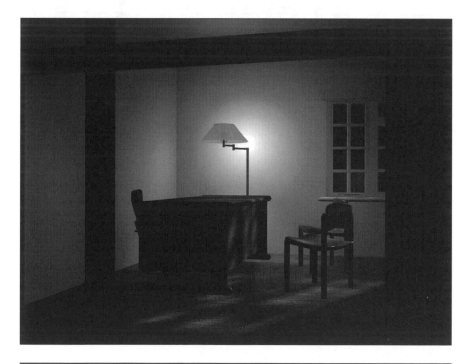

FIGURE 4.2

Composing the shot through the window not only adds a graphic element but also gives the audience a point of view that emphasizes the themes of the story. Looking through the window creates the feeling of being a peeping Tom, an occupation with many similarities to a private detective.

 PLAYTIME

Creating a film noir look means composing your shots graphically based on the shapes formed by the light and shadow in the scene. Any scene can be lit in this fashion, though some are easier than others. Light and frame a scene you have created for the maximum graphic impact.

- Light the scene in silhouette, revealing location and characters using only their outlines.

- Add some interference, such as a doorway, between the light source and the set. Try several positions for the light and observe how each position changes the composition of the scene.

- Add a strong foreground element between the camera and the set.

- Relight the scene using several lights, but maintain the strong graphic quality.

Horror

Horror is a cousin to film noir. The subject matter often has the same dark mood, and the visual style often relies heavily on darkness as a compositional element. However, since the objective of horror

movies is to scare the audience, you must create an atmosphere in which the viewer believes that something bad is going to happen but doesn't know when. Visually your aim is to tease the audience, to make them feel as if the monster could pop out of the darkness at any moment. When it does emerge, the monster is usually larger than life—an ominous presence that frightens the characters and the audience alike. These terrifying qualities of the monster can be portrayed in many ways, including sound and makeup (or in our case modeling), but it is how the character is presented onscreen that has the most impact.

The lighting for horror films tends to be stylized—used for its dramatic rather than realistic effect. Often lights are placed without regard to motivation in order to influence the mood and characters in a particular way. For example, characters might be lit from below, as you might use a flashlight to light your face when telling ghost stories, to make them appear more menacing. Like noir, horror often uses lights streaming in from behind a character to create a silhouette; however, usually the silhouette effect is not complete because light is cast on the front of the character as well, revealing his face (this is important because the producer spent a lot of money on that rubber monster suit). Horror films are spectacular by nature, and the audience is willing to accept lighting that makes the film dramatic at the expense of its realism. Color, too, is used without logical motivation and is based on its emotional effect. Effects lighting serves to create other-worldly glows and other motivated but unusual lights.

Where film noir tends to be very stark in its visuals, horror often uses diffusion to create a murky quality. The classic dry-ice fog, ubiquitous in vampire movies, is an example. Like darkness it can be used to establish the tone of the film. As used in noir films, darkness keeps the viewer from getting extraneous information, while fog allows some information but keeps it vague. If you show the teen hero approaching his friends in the graveyard, there is little dramatic tension—as soon as viewers see him they know who he is and where he's going. If he pops out of the darkness, the audience

may be startled for a moment but there is no time for real fear. If, on the other hand, the graveyard is filled with fog, the viewer sees a figure approaching the kids but doesn't know who it is or what its intention may be. This creates a sense of anticipation and fear stemming from the uncertainty of what is going to happen. A little information can be much scarier than no information at all.

In horror films, the camera is often used to give the scene an eerie aura and to make the villian more menacing. For example, it may be placed near the ground to make him look big and powerful. Or, when the shot is of the high school kids about to meet their doom in the back seat of dad's station wagon, it may be placed above them to emphasize their powerlessness. In a chase scene the camera may be rolled to one side or the other to make the audience feel off balance, helping them identify with the terror and confusion of the protagonist. As with lighting, the stylized nature of a horror film frees the camera, allowing composition to be used for dramatic effect.

Take a Look

Figure 4.3 proves once and for all that Woodrow is really a blood-sucking zombie from beyond the grave. The light streaming from behind him makes him appear both ominous and powerful. Fog fills the scene, keeping it murky and mysterious. The camera is slightly rolled, giving the scene an unbalanced feeling.

The lights in the scene consist of a strong shadow-casting spotlight behind Woodrow and the gravestone; an omni light at the same position lighting the background objects; a low-intensity fill light in front of Woodrow adding just a little light to the shadows cast by the spotlight; and a kicker adding light to Woodrow's face. This setup creates strongly back-lit foreground objects that are in front of more muted background objects. The muted background is a result of the layer of fog in front of it.

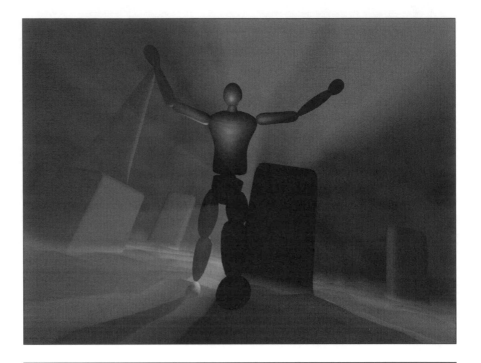

FIGURE 4.3

There are two different types of fog in this shot. The first is the ground fog that finds its way into almost every horror movie. It is created with a simple layered, translucent effect, a standard atmospheric option in many animation packages. If that option is not available, the effect can be easily reproduced by transparency mapping on a plane that is above the ground. A random, noisy transparency map applied to a self-illuminated plane that lies parallel to the ground, but slightly above, creates the illusion. The fog may wear a bit thin where it intersects other objects, but tweaking the map itself will make the areas around objects more transparent. This method is a good example of the rule that the simplest methods are often the best. As digital cinematographers we have so many cool tools at our disposal that we often forget that great effects can be created with very simple tools.

The second variety of fog in the scene comes from a volumetric light. The spotlight behind Woodrow has had an atmospheric effect applied to it that puts fog within the volume of the light's cone. It is this effect that creates the beams of light streaming toward the camera. Volumetric lighting is very difficult to fake with other tools because it actually creates a three-dimensional substance to the light. The shadows cast by the light affect the lighting of the fog in the cone, creating a very realistic effect. A smoke-filled pool of light in a seedy bar is the classic example of a volumetric light. The light affects both the objects below and the smoke itself, casting shadows through the smoke if something enters the light's cone. Because scenes with a lot of volumetric lighting can take excruciatingly long to render, it is best to use them sparingly to add accent to a scene, rather than trying to fill the whole scene with volumetric fog.

For this shot the camera has been placed low to the ground, making Woodrow appear large and threatening. A very wide-angle lens adds some distortion and makes the foot coming forward look disproportionately large. A slight roll has been added to create the feeling that the world is out of balance. The roll is emphasized by the fact that Woodrow is leaning into it. He appears to be standing straight while the world is tilted. In fact, the opposite is true: Woodrow is tilted and the ground is straight, but the roll of the camera compensates for this and makes it appear otherwise.

 PLAYTIME

Visuals play a big role in the fear factor of a horror film, influencing whether it actually scares viewers or makes them laugh. As the digital cinematographer for a horror piece, you must use the lights, camera, and atmosphere to add this level of terror to the film. Create a simple scene, such as a graveyard, and light and frame it to be as scary as possible. Don't worry about motivation for the lights or camera; focus on the dramatic effect.

- Set up the basic lighting. Use a strong back light behind the character.

- Light the background separately from the foreground.

- Add a layer of ground fog. Do this either with an atmospheric effect or by faking it with a translucent plane.

- Place the camera low to the ground to emphasize the menace of the character.

- Try rolling the camera in different ways to make the shot seem out of balance.

- Make the light behind the character volumetric. Adjust the settings to get streaks of light shooting out past the figure.

Cartoons and Comedy

Traditional cartoons are flat by their very nature. They are created in 2D, usually with no effort to make them appear otherwise. This causes a bit of a conundrum if you are trying to get the "cartoon" look in 3D. Traditional animation uses dark outlines around cartoon objects to separate them from other objects in the scene. When rendering 3D scenes, without the use of special image processing, you must use light and shadow to maintain the definition of characters and objects. At the same time you want to avoid a lot of contrast in the image. Color is very helpful in separating objects in an evenly lit scene; even traditional animation uses color to this effect. Chapter 9 teaches you how to achieve 3D characters using color.

If you look at the Three Stooges or Laurel and Hardy movies, you will notice that the light is very flat and everything is bright. This is called comedy lighting, and the theory is that because comedy is a

happy affair the visual style should be bright and cheery also. In the making of a comedy film the traditional focus was on making it funny, not making it look sleek or stylish. This idea is now on the wane, and many comedy films today put just as much effort into their look as do dramas or adventures.

If you want a bright, cartoony look to your images you need to add a lot of light to the scene. The trick is to keep the scene visually interesting as well. Shadows can be used to add texture without making the scene darker. Strong fill lights can be used to make sure the characters are always evenly lit and that the shadowed areas don't become too dark.

Composition is very important in creating a cartoon. The right camera position and lens will create and add to its surreal quality. A wide-angle lens distorts the image, making it more stylized, and also helps to separate foreground from background. By stretching the distance away from the camera, the wide-angle lens helps separate things near the camera from those far away. The framing of characters can be combined with the wide lens to create a shot in which the character is large and distorted in front of a normal background. Rolling the camera to create a tilted shot can also add to the visual impact of the scene by throwing it off balance.

When framing a scene, you usually work to deemphasize the edges of the frame. As a rule, you don't want the viewer's attention drawn to the frame edge because it erodes the illusion of reality, making the viewer actively aware of watching a movie. A character half on-screen and half offscreen usually looks awkward, or even unsettling. Cartoons break this rule. They free you to be self-conscious with the camera, to use it in ways that call attention to itself. Characters can use the edge of the frame as if it were part of their world. They can grab it and drag it with them, pulling the camera along, or exit the scene by stepping out of frame. All the rules about keeping the camera invisible can be broken.

TIP: If you want to create the traditional cartoon look in 3D, there are plug-ins available for many animation packages that do this by reducing the number of colors in the palette and adding black outlines around objects to simulate drawn lines. Some of these plug-ins do a very good job, though they tend to work best at creating an *anime* style, like Japanese animation, in which the characters and objects tend towards realism rather than stylization.

Take a Look

Just because the lighting is even doesn't mean that cartoon visuals have to be boring. The shot of the coffee shop in Figure 4.4 is lit with comedy lighting, keeping the monkey well illuminated at all times. The shadows and framing add visual interest to the shot without darkening the scene. The lower portion of the screen exhibits some strong contrast, with dark stools and hard shadows against the light counter, but nothing is happening in this area so the shadows will not obscure any action or character. Some very soft shadows fall on the monkey as well, but are washed out by other lights. The breaking of the edge of the frame adds another visually interesting element.

The even illumination in this scene was achieved with many lights. The monkey has key, fill, back, and kicker lights, several of which double as set lights. The key light for the whole scene, monkey included, is a shadow-casting spotlight with a projection map that makes it appear to be shining through a set of slatted blinds. The map, which is like a slide the light projects through, has lines of a medium gray on a white background. The light is at full intensity in the white areas and at about half intensity in the gray areas. The shadow lines cast in the scene are not too dark because even the gray areas allow light through. Look at the area below the counter where the stools are casting shadows and you can see how soft the

FIGURE 4.4

projected shadows are in comparison with shadows cast by objects in the scene.

The scene's fill light is provided by many sources. A general fill light is positioned from below, approximating light bouncing off the floor. As a directional light it does not cast shadows. Three shadow-casting spotlights are lined up over the bar, pointing down. Their cones overlap, bathing the whole bar, and the stools in front. A third fill position is used exclusively for the monkey, a spotlight from his right side that affects him alone, excluding the rest of the scene.

The monkey also has a back light, from the left and below that fills in dark areas on his leg and shoulders and helps pop him out of the background. A kicker light has been added for his teeth to give him

a radiant smile. The coffee cup he is holding has a kicker as well, adding extra light to the top edge.

The camera uses a wide lens to add depth and a slight distortion to the shot. Its position and angle are bland, without extremes, but the framing makes use of the curved counter and the stools to keep the composition interesting. The most striking thing about the framing is the monkey and how he interacts with the edge of the frame. Rather than trying to keep the frame's edges invisible, this shot uses them in the classic cartoon technique of being self-conscious about the nature of the medium and exploiting that in the actions of the characters. As well as breaking the edge of the frame, the monkey breaks the normal rules of orientation. Generally we expect a character to share the orientation of the set—head at the top of the screen, feet on the ground. The monkey does just the opposite, hanging into the shot from the top. Basic as it may sound, upside down is funny.

 PLAYTIME

Lighting for comedy is at best under-emphasized. The focus is on presenting funny material, not dramatic illumination. What is exciting about composing shots for cartoons is the freedom to play with the rules of framing. The genre's self-consciousness allows you to use the frame as if it were part of the set. Experiment with the rules of framing, breaking as many as you can.

- Frame a shot in which the character breaks the edge of the frame.

- Make the character interact with the frame, conscious that it is there.

- Try adding an extreme camera position, very low or very high.

- Play with different lens lengths, using the lens to add distortion to the scene.

- Make the character play to the lens, as if interacting directly with the audience.

Cinema Verité

Cinema verité is the tradition of movies made in the real world, without sets. The look and style of the cinematography is like that of a documentary, with existing light and hand-held cameras used to capture pieces of real life on film. In the analog world, cinema verité style is easy—get a movie camera and start shooting. In the world of computer graphics, however, extra work is needed to achieve that organic, spontaneous quality. The shake of the camera, the lens flares, and the unintentional walk-ons must all be carefully created to make the scene play as though it were entirely natural.

Adding "mistakes" to computer images can heighten the impact of scenes meant to seem unscripted, because the audience expects them. Viewers associate certain cinematic features with particular subjects and styles. They know that a game show will have bright, flat light and a squeaky-clean look. They know that the news will have some guy in front of a hand-held camera waiting for a tornado to swallow him up. They know that "America's Most Reclusive Terrorists" will have a sensational tabloid style, with dramatic recreations that are just like the real thing except that they're staged better. When you add elements like these to your scene that appear unplanned, the viewer gets a cue that these images were captured in the real world.

The movement of the camera is a key element in a verité style. The camera should react to the environment. In Hollywood great care is taken to make the camera invisible. Rain doesn't fall on the lens,

explosions don't knock over the tripod, lights don't flare into the lens. The action is carefully blocked, so there will be no surprises. It is the reaction of the camera to the unexpected that creates the feeling of realism in cinema verité.

If you want to create a believable home video of a UFO, you must add elements that make it appear spontaneous. Camera shake makes it seem as though an amateur is behind the camera. A shot that follows the craft and keeps it off center gives the impression that the cameraman is reacting to the movement rather than following predetermined choreography. An image with low contrast and a little grain creates the illusion of being shot with a camcorder rather than professional video equipment.

Take a Look

Figure 4.5 is a frame from a faux battlefield film (verite.avi on the included CD-ROM). All the light in the scene comes from motivated sources, though only the explosion actually appears onscreen. A dim overhead directional light creates the effect of sun on an overcast morning, and a spotlight shines from the direction of the camera, as if a video light were mounted atop it. Fill is provided by an omni behind the camera, simulating light bouncing off the ground.

The light from the explosion is created with an animated omni light that increases both its intensity and the range of attenuation in synch with the explosion. It only casts light when the physical effect (the explosion) occurs onscreen. At full intensity, the omni is about four times brighter than either the sunlight or the video light. Other omni lights are used to create the flashes of explosions in the background, reflected on the sky. The illumination from these lights is attenuated and does not affect the foreground at all.

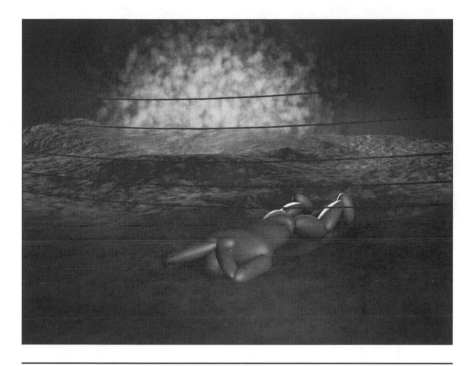

FIGURE 4.5

The natural light in the shot establishes that it was created on location, but it is the action of the camera that gives this scene a documentary quality. The image is framed as if the camera is being held on the shoulder of the cameraman—steady at first but reacting violently to the explosion and losing the subject entirely as it is thrown around. This places the cameraman in the action and makes the explosion seem unexpected. After the shake the camera reframes on the subject. The actions of the camera give the viewer information about who is behind it. A professional newsman will be much quicker to regain composure than an amateur with a camcorder. Viewers expect that battlefield footage will be shot by a professional rather than a random passerby, so this adds to the credibility of the shot.

The camera's reaction to the explosion is created with carefully keyframed movements of the camera and its target. The beginning of the explosion is captured on film, before the shockwave reaches the cameraman. When the shock hits, the cameraman is knocked around, losing the subject, recording seemingly random images of the ground and sky. The movements are not random, however, but precisely choreographed to appear as if the camera remains with its operator, who regains control after the explosion.

The overhead light is assigned an atmospheric effect, adding animated volumetric fog blowing through the scene like smoke. This is done with a volume light like the one demonstrated in the section on horror. As with that previous example, fog can be faked using planar objects with opacity maps. In this instance the planar object would be parallel to the camera's lens and placed between the lens and the subject.

 PLAYTIME

The cinema verité look is not stylized; indeed, it is the intentional lack of style that gives it validity. To create this look all the lights must appear motivated. They should be positioned to seem appropriate to the space without apparent regard for the camera. The credibility of the shot can actually be increased by adding lens flares and awkward shadows. Still, it is the camera that defines this style. By making the camera interact with the scene, consciously acknowledging its presence, you create the illusion that the scene is unscripted. Take a scene of your own devising and see if you can instill these elements.

- Light the scene using only motivated lights.

- Add some "unintentional" glitches, such as blown out highlights on the character—areas where the light is so intense that it obscures detail.

- Make the camera react to the scene, following movements rather the preceding them.

- Add a physical interaction with the camera, such as someone bumping the cameraman.

- Try creating a version of the shot as if it were shot by an amateur. Add more camera shake and compose the shot in a more awkward fashion, as if the camera operator were unfamiliar with composition.

Wrap-Up

The tools and techniques shown in this chapter can be used in any genre, and the scope of each genre presented is much greater than can be covered in a single chapter. If you want to learn the visual aspects of different film genres, you need only go to the local video store and rent some movies. The best reference in the world is the work of other craftsmen. You can see not only how they have used the traditions of the genre but also how they have adhered to or broken with them to present that film's specific message.

There are many genres and visual styles not covered here. They are just as important and valid as the ones that are covered, but they are too numerous to include in a single chapter, or even an entire book. What you should get from this chapter is some insight into using the visual style of cinematography to emphasize the themes of the narrative.

5

Motion

The techniques of the digital cinematographer that we have explored thus far have, for the most part, been applied to static images. Obviously, however, motion is an integral part of the craft of a cinematographer. You will deal with three basic types of motion in your scenes. The first is character motion: motion within the scene that the cinematographer records, but does not create. The second is camera motion. When capturing images, it is often more effective to have the camera move. Sometimes this movement is designed to add an element to the plot; other times it is for following a moving element in the scene. The third type of motion is light movement. This includes animated light positions, animated target positions, and animated values. As you begin to incorporate movement into your scenes, you should continue to use all the techniques discussed in previous chapters. In this chapter we will look at concepts and methods that are concerned specifically with motion of both camera and light.

The motion of characters within the scene will be examined in a later chapter that deals specifically with photographing characters.

There are many ways to use movement in creating a visual sequence. The camera or light can be moved to follow a character within the scene, or it can be used to reveal the scene over a period of time. Often the camera is moved through the location of the scene in an introductory shot. Think of how many movies begin with the camera moving through the town where the story takes place. This is using movement to further the plot—to give the viewer information on the locale of the story. Lights may be used in a similar fashion. The classic example is the time-lapse shot of the sun rising over town, revealing it bit by bit from the darkness.

JARGON: *Time-lapse* photography is the technique of photographing a scene in intervals that are much longer than the actual rate at which the scenes will be played back. The shot you saw at assembly in elementary school of the flower sprouting up from the ground and blooming was done with time-lapse photography. The flower is photographed at long intervals, perhaps once an hour, but when that film is run through a movie projector at 24 frames per second, you will see the progress of the flower at a greatly increased rate. If it is shot at one frame an hour, each day in the flower's development will take one second on the screen. Of course, in the world of computer animation you don't have to wait an hour between frames. You can increase or decrease the speed of motion simply by adjusting the length of your animation or by rendering only every third or tenth (or nth) frame.

Camera Movement

Camera movement has been a part of movie making almost from the beginning. It was one of the great wonders of motion pictures. Not only could you record movement that was occurring in front of the camera, you could also move the camera to follow the motion. In the

century since motion pictures were first developed, many types of camera movement have been tried, and many devices have been invented or adapted to make moving the camera easier.

Cinematographers routinely mount cameras on moving platforms such as cars and helicopters. They also use special mechanical rigs to smooth the motion of walking with the camera. Dollies—little wheeled carts designed specifically for camera mounting—are standard on every movie set. As a digital cinematographer you don't have to worry about the mechanical aspects of moving your camera. You have at your disposal a camera that is capable of any movement without the need for special equipment. Nevertheless, you do need to worry about how to move your camera and why.

In this section we will look at different ways of moving the camera. While your digital camera is unfettered, it is still important to look at the different kinds of camera motion used by traditional cinematographers for two reasons. First, it will be easier to learn this complex set of tools in discrete pieces; with a working knowledge of the basic camera movements, it will be easy for you to combine them to create complex movement. Second, these are the terms and divisions that both cinematographers and viewers are familiar with.

Just because you can move your camera from outer space to inside a fish tank by following a spiral path and zooming in and out, doesn't mean you should. Audiences are familiar with certain types of camera movement, and it is important to keep these in mind as you design the movement for your scenes. However, you should not feel constrained to moving the camera only in ways that have been done before, instead you should think about how the viewer will react to a camera move that is totally unfamiliar. Almost all the photography in *Toy Story*, the first computer-generated feature film, was constrained to movement and positions that were possible with real cameras. The reason for this was not that the filmmakers had to obey some obscure set of natural laws but because that is what viewers are used to. If you want people to relate to the images you are presenting, and hence the project that the images are a part of,

you need to present them in a way that is somewhat familiar. *Toy Story* felt more real because the camera was used in the same way it would have been in a live-action film. If you are dead set on that space-to-fish tank shot, then by all means go for it, but make sure that you have motivation for such a shot that the audience will understand.

Panning and Tilting

The most basic camera movements are pan and tilt. Panning is rotating the camera on a side-to-side axis (parallel to the ground); tilting is rotating it on an up-and-down axis. In both cases the camera does not change location, it simply changes orientation. By the nature of their simplicity, pans and tilts are easy to plan and carry out, but such simplicity does not reduce their usefulness in telling the story through the camera. This kind of movement is easy to work into the flow of a sequence because it feels natural to the viewer. When we watch an event, our tendency is to stand still and move our heads—that is, only changing the orientation of our eyes. Panning and tilting the camera from a fixed position mimics this behavior and therefore feels instinctively correct to the viewer.

There are two basic ways that pans and tilts are used in a sequence. The first is to reveal what the camera sees. The tilting shot from the outlaw's black cowboy boots up his body to his smug face framed in a black 10-gallon hat is an example of tilting to reveal the subject. A pan might be used to move down the bar to the face of our hero drowning his sorrows in a whiskey bottle because he has to fight this same villain at sunup. In both of these shots, the movement of the camera produces an intentionally paced revelation of information to the audience. A sequence of information may be revealed in such a

way that it builds to a crescendo. The plight of the subject may be disclosed through showing his environment. As the camera pans down that bar past the desperate faces of scared, drunken men, the gravity of the hero's situation is driven home. Traveling up the heavy's body, we see he is wearing our hero's own pearl-handled pistols, which reinforces his desperate villainy. Both of these shots and similar ones, like a pan through the town at the start of the movie, are designed to set the scene for the audience. Whatever other action is occurring, the audience is being fed specific visual information that informs them about the content and context of the scene. As a novelist describes in detail the tailored clothing and twisted face of the outlaw, a filmmaker uses a revealing shot to impart the same descriptive information to the audience. In both cases detail is described to flavor the action.

Pans and tilts are also used to follow the action of the sequence. Again, this mimics our own natural way of observing things. When we watch a person perform an action, we don't lock our head into place and let her move around in our field of vision. We follow the action we are watching—our eyes track the person we are looking at. This is what the camera is doing when it pans or tilts to follow the action. When our hero gets up from the bar to go outside and face his destiny, the camera tracks him as he makes his way to the saloon doors. The camera watches the hero just as we would if we were sitting at the other end of the bar.

Like our own eyes, the camera may switch subjects as it moves. The shot may begin following the village blacksmith and switch to the madam as he passes her in the street. From the madam the camera might pause as she passes the sheriff's office and focus on the sheriff discussing the local rustlers with his deputy. However much the camera switches subjects, its use is still the same: to follow the action of a character. In this case it may do double duty as a revealing shot. As we follow the action, we also learn about the town it is set in.

Watching the Action

As an example, let's look at a simple panning shot that reveals the locale of our subject, in this case a cartoon hyena. The shot reveals the hyena's neighborhood to us as it pans to look at him. There is not much action going on, but the atmosphere of the hills with the weird trees is imparted as our point of view travels over them to find our subject. Additional elements in the final scene may help motivate the shot. The audience might hear the hyena's laugh as the shot begins. The movement of the camera, especially if orchestrated with an increase in volume, will be motivated by our natural desire to see the source of the laughter.

The whole shot of the hyena is represented by a series of five images (Figures 5.1 through 5.5, pan.avi on the CD-ROM), which are frames extracted from the sequence. It begins with a tree on a hill (Figure 5.1). On the sound cue of the hyena's laughter, the camera begins panning across the hill (Figure 5.2). The shot reveals a lonely green hill dotted with trees (Figure 5.3). The hyena appears on the left side of the screen (Figure 5.4). Finally, the camera comes to rest on the hyena as he strolls the glade (Figure 5.5).

These images represent a very simple use of panning to reveal the subject. The camera begins framed on the tree and then moves across to rest on the hyena. If you look at the sequence of stills, you will notice that the distance traveled between frame 1 and frame 2 seems less than the distance between frame 2 and frame 3. Again, between frame 4 and frame 5, the camera doesn't seem to move as far. The reason is that the camera is actually moving slower at the beginning and end of the shot.

The slowing of the camera is called easing in or easing out. The camera eases out from the tree, slowly accelerating. Once at full throttle it begins slowing down as it nears the end of the shot. Easing in and out helps to keep the shot smooth. For the most part you will want some ease in and ease out in any pan or tilt, but sometimes you

FIGURE 5.1

FIGURE 5.2

FIGURE 5.3

FIGURE 5.4

FIGURE 5.5

may not. When simulating documentary-style footage or the *cinema verité* look, there are times when you want to whip the camera around without warning. The whip pan, where you pan so fast that the scene is no longer recognized, can be used to cut between scenes.

Tilts and pans are usually combined into one motion. The camera will go up and down and side to side simultaneously to follow action or reveal a scene. The most important thing is to keep delivering more information to the viewer as the shot goes on. Use the movement of the camera to make your scene richer by adding more information and more layers. If a moving shot doesn't follow action or reveal information or create a specific mood or style, then it shouldn't be moving.

TIP: Camera movement is always less intrusive when it is motivated in the scene. If the camera is following a character, the viewer knows why it is moving and isn't confused or interrupted. If the camera moves for no reason, the viewer may stop being involved in the action to wonder why. Motivation doesn't have to be directly visual. For example, the camera may track to find the source of a sound or follow a sound coming from an unseen source. Using movement to reveal information is a natural action when you begin a scene; the viewer will understand the motivation of the camera examining a new situation. But if the viewer is already familiar with the location and context of the scene, panning around is not revealing anything to her and doesn't feel natural.

However you move the camera, the audience should understand the motivation almost immediately. The viewer should see the action being followed, hear the sound that the camera turns toward, or learn new information as the camera moves.

PLAYTIME

See if you can develop a feel for moving the camera by playing with some tilts and pans. Set up a scene that contains enough objects for a revealing shot and place a character in it. Set the camera up to start on a shot of some object in the scene and pan or tilt to the character.

- Try both panning and tilting. For the tilt you might start with a shot of the sky.

- Try combining the pan and the tilt.

- Play with ease in and ease out. See how much you need to slow the camera at the start and finish to make the shot smooth.

- See if you can make the shot work without easing the movement. Try to use the abruptness as a stylistic element.

Dollying and Zooming

Dollying and zooming are different methods used to change how much of the scene is shown by the camera. Dollying or zooming in focuses the shot on less of the scene, while going out broadens the point of view. The difference between these two methods is in how they accomplish the change in scope.

Dollying is very simply moving the camera toward or away from the subject. If you want your character to be larger on the screen, it makes sense to move the camera toward her. If she is moving and you want her to remain the same size, you dolly with her. Like panning and tilting, a dolly shot can reveal the scene. Used this way, it can be more self-conscious than a pan because the camera is moving, not just changing orientation. This can be a desirable effect if you are trying to create the feeling that the camera is the point of view of a character. Dolly shots are often used to follow action that is taking place while characters are moving.

Zooms are rarely used to follow action on the move. The reason is that zooms change the scope of the image in a very different way. Where dolly shots change the distance between the camera and the subject, zooms change the focal length of the lens. In traditional photography a zoom lens has variable focal length. In motion pictures the focal length can be adjusted while the camera is shooting, resulting in a shot where the field of view grows or shrinks without the camera changing position. The effect of a zoom is that the screen shows less or more of the scene but does not change perspective. In a dolly shot the perspective in the shot changes because the camera is actually changing location. Because there is no perspective change, a zoom shot tends to look rather flat. It is a look often associated with television, where many shows are shot from fixed camera positions. In some cases, like moving with action, dollies may work better than zooms. Most of the time the question of whether to dolly or zoom is an aesthetic one.

Audiences associate zooms and dollies with different styles of movie making. Dollying shots tend to evoke the Hollywood style of smooth, seamless camera movement. That is not to say a dolly shot will always be smooth; it is simply a stylistic convention used in big-budget movies. Zooms are more often associated with TV and low-budget, guerrilla films. If you are trying for the documentary look or a mock TV show, zooms may be the ideal choice. The choice may also depend on what the shot represents. If your shot is the point of view of a killer robot, a zoom will help to reinforce the mechanical feel. If it is the point of view of a pilot, you want to use a dolly shot to get the sense of real motion.

Look at Both

The zoom shot (Figures 5.6 through 5.9, zoom.avi on the CD-ROM) and dolly shot (Figures 5.10 through 5.13, dolly.avi on the CD-ROM) in the example begin in the same position and end with the subject at the same size onscreen. The difference is in how the perspective changes. In the dolly shot the perspective is changing all the time. In the zoom it doesn't change at all. Compare the shots in each sequence one by one and look at how the screen image changes over the course of the shot. Pay particular attention to the trees in the scene. In the dolly shot you actually move past the trees, whereas in the zoom the trees just drift off the side of the screen as the shot gets tighter. The dolly feels more active than the zoom because the change of perspective gives us the point of view of walking toward the subject. The zoom feels more as if we are focusing in with a telescope.

FIGURE 5.6

FIGURE 5.7

FIGURE 5.8

FIGURE 5.9

FIGURE 5.10

FIGURE 5.11

FIGURE 5.12

FIGURE 5.13

 PLAYTIME

Try setting up a scene similar to the one in the example. Start with the camera far away from the subject and move in. Next, create two cameras. Make the first a dollying shot where you change the camera's position to enlarge the subject onscreen and create a zoom for the second camera.

- Compare your own zoom and dolly shots to see how they look different.

- Add ease ins and ease outs to the shots and see how they change things.

- Try zooming and dollying out instead of in. Are the differences as noticeable on reverse?

- Create shots that use the respective effects of zooming and dollying to enhance the aesthetic of the shot.

Vertigo Shots

Vertigo shots combine dollying and zooming. In a vertigo shot the subject stays the same size on the screen but the focal length of the lens changes, altering the field of view. This is accomplished by dollying in and zooming out simultaneously or vice versa. Like a revealing shot, vertigo shots are used to give the viewer information about the character's situation or state of mind, and the effect is quite dramatic. The character doesn't seem to move, but the background expands or contracts behind him.

A vertigo shot is often used to indicate the character's state of mind or a change in his perspective. A good example is in the movie *Jaws* when the shark is spotted by a beach full of bathers. The camera is

in a tight shot on the main character when there is a scream indicating the presence of the shark. The character remains the same size on the screen, but the background opens up behind him. The perspective change is used to show that the character is suddenly out of control. At the beginning of the shot, he is alone onscreen, in control of his environment. At the end of the shot, you can see a whole beach of panicked beachgoers around him.

It is important to plan carefully when using a vertigo shot because it is a very self-conscious camera move. If there is not sufficient motivation in the minds of the audience, the shot will stick out like a sore thumb. The viewer must understand that it represents an internal change in the character. If played right, this shot can be very effective in communicating changes in the character's situation.

Take a Look

In the example sequence (Figures 5.14 through 5.17, vertigo.avi on the CD-ROM), the camera is focused on our old friend the hyena, walking in the glade with the weird trees. In this sequence the camera is trying to let the audience know that the hyena's world is opening up around him—perhaps he just quit his job as a scavenger and is off to make it in Hollywood. The shot starts very tight on the character (Figure 5.14) and broadens out to show the vast open space around him (Figure 5.17). The camera is dollying towards him at the same time it is zooming out. The hyena doesn't change size in the frame, but you can see that the focal length of the lens is getting wider. In frame 3 (Figure 5.16) the trees come into view and appear to be not too far behind the hyena. By the end of the shot (Figure 5.17), the trees seem to be a long way off, because as the lens gets wider it expands the apparent distance.

You will probably notice that the full animated version of this shot on the accompanying CD-ROM looks a bit stilted. Because the shot

FIGURE 5.14

FIGURE 5.15

FIGURE 5.16

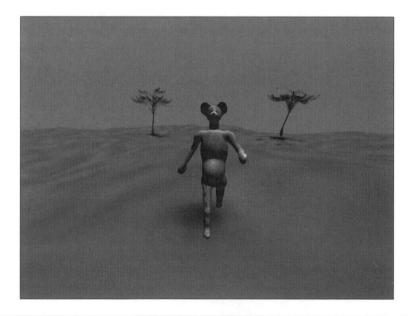

FIGURE 5.17

is isolated from any real story, there is no motivation established, and you end up focusing your attention on the mechanics of the shot. Integrated into the story line, as a complete sequence, this shot would not distract the viewer from the action. As with any camera technique, vertigo shots must fit into the stylistic and narrative flow of the scene. If you are working in a medium that is not narrative, you may not need to worry so much about narrative flow, but you will still want to make sure the shot fits with the style of the piece.

One of the trickiest parts of setting up a vertigo shot is that you don't want to dolly and zoom at the same speed. When the lens is at a longer focal length it compresses the distance and the characters change in size as the camera moves in is reduced. As the lens gets wider the change in size happens more rapidly. The result is that you may need to move the camera at a different portion of the sequence than when the change in focal length takes place. In the example, the movement of the camera slows as it nears the subject, easing in a bit. The zoom, on the other hand, increases as the camera nears the subject. How you adjust the zoom to accord with the dolly depends on how the camera moves. There is no formula that can be written down.

 PLAYTIME

Setting up vertigo shots is very much a matter of practice. To get some experience set up a vertigo shot of your own. Place the camera a long distance from the subject and zoom in until he is in full view on the screen, with all of his body visible. Go to the end of the sequence and dolly the camera in so that it is right in front of the character. Zoom the lens out until he is the same size onscreen as he was at the beginning of the shot. As you play the sequence you will notice that although he is the same size at the beginning and end of the shot he doesn't stay that size all the way through. You will need to adjust the timing of both the dolly and the zoom to get the character to remain at the same size onscreen throughout the shot.

- Change the timing on the zoom until the character size is consistent through the whole shot.

- Reset the timing of the zoom and change the timing of the dolly to achieve the same effect.

- Add some ease ins and ease outs to the camera movement.

- Try the shot in reverse. Start with a wide lens close to the character and pull the camera back while zooming in.

Crane Shots

The crane shot is really just a variation on a dolly shot. Dolly shots are so named because in traditional cinematography they are accomplished by mounting the camera on a moveable dolly. Crane shots are taken with the camera mounted on a crane and are used when the camera must be moved up or down in the course of the shot. A tilt rotates the lens up and down, but doesn't physically move the camera. In a crane shot the camera is actually raised or lowered.

Crane shots are usually used to reveal the scene. Sometimes they are used for other purposes such as swooping down on a character. It is unusual in traditional cinematography to use a crane to follow the action because characters in the real world don't normally move up or down that much, they tend to stay on the ground. In animation this may not be so true and you should make use of the crane shot to follow action where appropriate.

Because you are not constrained by gravity and other annoying physical laws when working on the computer it makes sense to think of crane shots and dolly shots as being the same thing. Moving the camera has the same effect whether you move it parallel to the ground or perpendicular to it. The one difference between craning

and dollying is that raising or lowering the camera changes its height in relation to the character (assuming the character isn't moving up and down as well). Thus, the audience may read in some extra information when seeing a crane shot. In Chapter 3 we talked about using camera height to help the viewer understand the character's position. Crane shots involve the same aesthetics, but make them dynamic. When your hero loses the big kung fu fight and is humbled by the bad guy, you might use a crane shot pulling up and away to reinforce the sinking feeling of defeat.

Take a Look

In the example on the included CD-ROM (crane.avi), we are once again framed on our friend the hyena. In this shot the camera stars near him and at the same height, and then pulls away and up until he is only a speck. The camera motion in this shot combines a crane and dolly shot, moving both up and away. It is unusual to have a shot where the camera moves vertically and not laterally.

As the camera pulls away the audience sees that he is only a little speck in a big world. The high camera also distances the audience from the character. They are now observing him from above.

Motion Blur

Motion blur is an effect that occurs in real movies all the time, or at least whenever there is motion. Analog cameras capture images by opening a shutter and letting in light. If the camera or subject is moving while the shutter is open then the image gets slightly blurred. When you watch a movie you don't notice this blur because

it is small and because your brain filters it out. When you do notice it, however, is when it isn't there. Think about the monsters in the old Sinbad (the hero, not the comedian) movies. They looked cool but they moved in a rather jerky fashion. Part of the reason they seemed jerky is that they did not have any motion blur. Those monsters were animated in stop motion. One frame was taken, the model was moved, and another frame was taken. When shown in sequence the frames created the illusion of movement, but because the models were not moving as each frame was exposed, there was no motion blur, causing the action to look stilted.

A little bit of motion blur can make an action seem much smoother. This is especially true if it is a fast action where the distance traveled in each frame is great. In effect you are photographing a series of positions and blurring them together. Motion blur may also be introduced into a scene to create the impression of very fast movement. Blurred images make the camera appear to be moving quickly.

Because it does not occur naturally, you must tell your computer to add motion blur to the images. The settings for doing this vary from program to program but all use the same basic technique. Instead of rendering a single image for each frame, several images are rendered and then combined. These images cover a short, sequential span of time—no more than a frame. When combined the areas of the frame that are moving have several overlapping parts which create the blur effect. If something in the frame does not move then all the images line up with each other and no blur is created.

Take a Look

When the camera is moving the whole scene will be blurred by the motion. If the camera is moving very fast the motion blur will help smooth the motion. If the camera is not really moving that fast then the blur will help to create the impression that it is. The sample shot

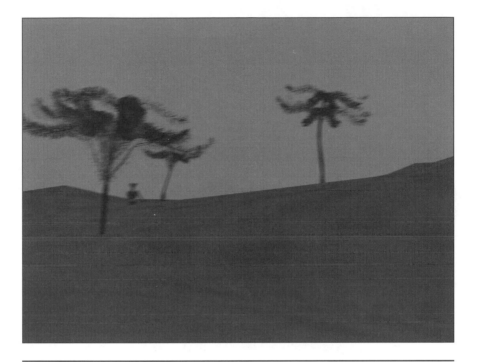

FIGURE 5.18

(Figure 5.18) is one of the frames from the pan we looked at earlier in this chapter. Motion blur has been added. In this case the amount of blur will make the camera appear to be going faster than it actually is. Instead of a single image five separate images were rendered and then blended together to create the blur effect. For this particular image that amount of motion blur may be overkill but it shows what the effect does.

Animating Lights

Animating or adding motion to your lights is a simpler concept than camera animation. This is because light motion is almost always motivated by action in the scene. When you move a light it is because the light source, whether onscreen or offscreen, is moving. Occasionally you may use lights that move just for the stylistic effect. In these cases, how you move the light is completely dictated by the aesthetic of the piece you are working on. In most cases when the light moves the movement is dictated by the apparent source of the light. If the light is coming from a car's headlamp, it will move with the car. If it is coming from a search light, it will move as a search light does, swinging in a circle around a fixed point.

Some light animation does not involve moving the light but varying how bright it is. Again this will be motivated by the apparent light source. You know how a light acts when the light switch is flicked—either it goes on or off.

The most important aspect of animating lights is the choreography. When a spotlight moves across the scene you want to plan the motion carefully to get the most effect out of it. It is important to look at how the scene is affected as the light moves across. Does it highlight the important things? Does it reveal something too soon? These are the kind of questions you need to ask as you plan the motion.

The technical aspects of animating a light are very simple. Lights or targets are almost always animated in the same way objects are. You define keyframed movements for the light. Animated intensity is usually keyframed as well. Which of these elements or combination of elements you animate is still dictated by the scene itself.

JARGON: *Keyframing* is the simplest form of animating on the computer. The transforms of an object—position, rotation, and scale—are assigned different values at specific frames. A frame that has a new value setting for a transform is a keyframe.

Any frame can be a keyframe but not every one has to be. The computer looks at the value of a transform at one keyframe and then at the value of the next keyframe, and smoothly interpolates the values over the intervening frames. If you have a ball that is at point A on frame 0 and at point B, 100 feet away, at frame 30, the computer interpolates the in-between frames. At frame 15 the ball has moved 50 feet toward point B.

Animating the Light

With omni or point lights, which have no target and project equally in all directions, physical translation is the only kind of motion. If you want to move one of these lights, you just keyframe the movement. With a spotlight, which has a target, you can still do this and you have the option of not animating the target. The effect of animating the light and not the target is that the same spot is illuminated but the direction of the illumination changes. A real-world example of this would be a spotlight from a helicopter. The light remains trained on the same spot but the source is constantly moving. In the sample on the CD-ROM (litemove.avi), the Blob Squad is walking through a misty undefined area with the light circling around them. The effect of this can be visually interesting because the shifting light adds another layer of movement in the scene.

Animating the Target

Many moving light sources having moving targets while the light itself remains fixed. Search lights are an excellent example of this. A search light stays in one place and rotates to change where the light is shining. Again this is technically easy. Keyframing the target without animating the light itself creates this effect. In the example

on the CD-ROM (trgtmove.avi), the squad is walking through the same misty area but this time the light is static and the target is moving. Again, the aesthetic effect is nice, especially with the mist catching the light.

Often you will animate both the light and the target. Sometimes they will both be animated but the animation will not be synchronized. If the helicopter circling overhead is scanning the ground for someone then both the light and the target will be animated but the animation will not be synchronized. At other times the animation will be synched and the light and the target will move in unison. Mostly, synched animation will be the result of incidental animation. If both the light and the target are linked to another object then the movement of that object will cause incidental animation of the light. A car headlamp is a good example, given that, relative to the car, neither the light nor the target moves. Within the scene both move as the car moves.

Animating Intensity

As with moving lights, animating the intensity of lights is often a function of the apparent source in the scene; when the light switch is flicked off, the light turns off. This is the most basic form of animating the intensity of a light, changing it from on to off. The brightness can also be adjusted to any point between on and off. The mechanics of animating the intensity of a light are very simple. As with moving a light you simply keyframe the change in brightness. You may use ease in and ease out in the animation to smooth the transition. The timing of the animation will usually be dictated by the light source in the scene.

There are many situations in which you will want to use animated intensity to simulate real light sources. Fire light requires constant animation of the luminance; simulated sunrise requires the light to be gradually increased. There are also situations where you will use a variable light for dramatic purposes. Light can be used very effectively in isolating a character within the context of a scene. To increase the dramatic impact of the actions of a particular character you may animate the intensity of the lights affecting that character. When the love struck hero sees the beautiful heroine across the room all the lights dim except those on her. She is pulled out of the scene and into the forefront of the action. The gas station attendant who is suddenly inspired by the great spirit suddenly has twice as much light on him. These examples are extreme but subtle uses can be made as well. In classic Hollywood movies the female star is often lit brighter than the rest of the cast. With animated intensity this can be accomplished as she moves through the scene. Bringing the lights up from darkness can also be used as a way to reveal the scene.

Take a Look

In the example the intensity of the light is gradually increased from zero to full (Figures 5.19 and 5.20, fadeup.avi on the CD-ROM). The Blob Squad is revealed as silhouettes walking in thick fog in an introductory shot. *Blob Squad: The Movie* begins in total darkness and the light gradually comes from behind our heroes as they walk along in the murk. Along with a pulsing soundtrack, this scene introduces the audience to the main characters. There isn't an obvious light source in the scene but it doesn't matter because the audience understands that in this instance the animated light is being used for dramatic purposes.

In the animation included on the CD-ROM (on-off.avi), another dramatic effect is simply turning lights on and off. In this age of the

FIGURE 5.19

FIGURE 5.20

music video, the strobe effect has become very popular. Here we have an excerpt from a music video that ties in with the movie. To add more visual excitement to the scene it is photographed using a strobe light. A small amount of fill light is cast from below to keep the characters from totally disappearing when the strobe is off. The strobe light emphasizes the sequential nature of the action. The scene is brightly lit for one frame and then dark for three frames. This creates a stylized flipbook quality to the image. This is accomplished by setting key frames that vary the intensity from zero to full without any intermediary steps.

 PLAYTIME

In this section you looked at animating lights in three ways. Most of the time these will be combined to some extent. Experiment with using lights both for motivated and dramatic effects.

- Create moving lights in a scene where they are simulating an onscreen light source.

- Try changing the speed of the light.

- Create a motivated light source with animated intensity.

- Try using the same lights for dramatic effect by bring them up and down in combinations that highlight the subject.

- Create some lights that are completely for dramatic effect. See if you can get that music video look.

Wrap-Up

Cinematography is by definition capturing moving images. Many of its techniques can be just as easily applied to still images, but some techniques are specific to motion. In this chapter we looked at methods of animating your camera and lights.

Movement can be a tricky effect to pull off, but it can make your scene much more dynamic. The key to motion of any kind is motivation—physical, such as following the movements of a character, or dramatic, using the movement to help the viewer understand a character's state of mind. Whatever motivation the movement has, it is critical that the audience understands the reason. Actually, you hope that the viewer isn't thinking, "Oh, she moved that camera to signify the distance between father and son." The motivation shouldn't register consciously, but should seem so natural that it simply blends with the telling of the story. The audience should feel the distance between father and son without being concious of the mechanics involved.

One of the most common mistakes among neophyte cinematographers is moving the camera for its own sake. This may add some energy to the scene, and if you are doing commercials or music videos, that may be enough. When you are creating a narrative, however, it is important not to let extraneous camera movement distract the audience from the story. If a camera or light is moving for good reason, it will enhance the quality of the narrative. If there is no reason for the movement, don't do it. Unmotivated movement dilutes the power of a scene and separates the viewer from the story.

6

Working with Characters

The proper presentation of a person, animal, or other figure in a scene is critical to involving the viewer in the action. Although the scenes you work with will not always contain characters, in those that do you must treat them as the most important elements. They are your actors, and the viewer will naturally be drawn to them. If you present a character poorly, the audience will lose focus on him and, as a result, on the whole scene. But a well-presented character can draw the viewer in regardless of what's around him. Traditional cartoons, in which the background is totally secondary to the character, exemplify this. Often a cartoon will have minimal or no background, but it doesn't affect the scene because the character itself holds the attention of the viewer.

Presenting characters well involves the same processes and tools that you use for all images. How you light and frame a character affects how the audience perceives her. Previous chapters referred to characters in outlining the principles of cinematography, so why devote a chapter to them? Because they are critical to the success of any animation and because many techniques have been invented specifically for photographing them. The treatment of characters often dictates what you do with the rest of a scene. Chances are, your scene is about the character and not about the brick wall behind her, so the lighting and framing used to illustrate her sets the tone for the overall effect of the image.

Lighting Characters

Lighting is dictated by where you want the attention of the audience. Since a character will always be the focus of a scene, the primary lighting task is to make him look how you want him to look. The set should then be lit with reference to how the characters are lit. Just as you spend more time modeling a character than a set piece, you should spend more time lighting him as well. A good rule of thumb is to spend as much time lighting each character as you do the entire set. This is not a hard and fast rule. Sometimes characters are easy to light and take less time; other times complex sets will require more effort. The key is to concentrate your energy on the most important elements of the scene.

The tools used for character lighting are the same ones used for lighting anything; all the instruments and positions mentioned in earlier chapters can and should be used. Nevertheless, some charac-ter-specific lighting positions make the character more dynamic or highlight his figure and personality. Often characters will have more light, that is, greater intensity, than the set. This brings them forward in the attention of the viewer.

Key Light

The key light for a character is the same as that for any subject—it is the main source of illumination. However, in working with characters you must consider not only the logical source of the light but how it interacts with the figure. Does a high key light complement her? How do her features interact with the light? Do the shadows fall in a way that emphasizes her personality? Ask yourself these questions as you set up the lights for your character. Remember that your lights have both a practical and an aesthetic purpose.

To demonstrate how each of the lights combines with the others to create the appropriate illumination, we have enlisted our friend the hyena. The first light to set up is the key, which is standard practice and not unique to working with a character. The main light source gives you a base from which to add the other lights. The key light on the hyena (Figure 6.1) is a strong side light, higher than the character but not too high, brightly illuminating his left side and letting the right side fall into total blackness.

Eye Light

The eye light is used exclusively for characters' eyes. You have certainly seen eye lights at work, although you didn't notice the good ones because the eyes appeared brighter but not so much that it registered consciously. As for the bad ones, how many times have you watched *Star Trek* and wondered why the captain had a bright band of light cutting across his eyes? The answer is low budgets and low production values. Still, that band was an eye light in its most basic form.

If the eyes are deep set, eye lights help bring them out of the shadows so that they can be seen. This is critical because we read

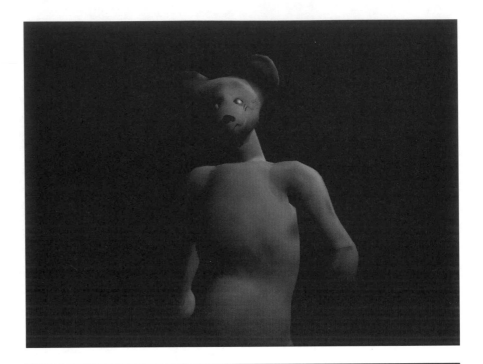

FIGURE 6.1

people (or cartoon characters) by looking at their eyes. Just ask yourself whether the state trooper is more threatening with or without his mirrored sunglasses. Even when working with a character whose eyes are not deep set, the eye light can add a glow, imparting extra vitality. The viewer understands instinctively that there is more light on the eyes because eyes are the key to understanding the character, to getting inside his head.

The trick to eye lights is to keep them subtle so that the viewer won't notice them. The eye light is there to heighten reality; it is not motivated but seems natural when used judiciously.

The hyena's eye light is a narrow band running across his face, which, seen alone (Figure 6.2) looks obvious. The important thing is

FIGURE 6.2

how it works with the other lights, since the combined effect creates the final image. You don't notice the slash of light across the face, but the eyes are highlighted, helping the viewer to focus there.

Kicker Light

As its name implies, the kicker light adds extra illumination to a character. Its use is similar to that of a back light. A back light is positioned based on the camera's position to add a delineating edge of light to the dark areas of the figure. The kicker is also used for delineation, but is positioned based on the position of the key light

to add brightness to the side opposite the key. Thus, if the key is high and left, the kicker will be low and right. The coordination of the key, fill, and kicker presents the subject in a way that pulls him out of the background.

Camera position is also a factor in placing the kicker because this light should only outline the object, not fully illuminate it. The hyena's kicker (Figure 6.3) is low and right, creating a strip of illumination along the right side of his body. This pulls him out of the background by creating a high-contrast outline. The strip blends with the eye light, as shown, and with other lights as well.

As with the back or eye light, the trick to using a kicker effectively is to keep it from being noticed. If it is noticeable, the viewer may wonder where it is originating. If the scene has a logical source for

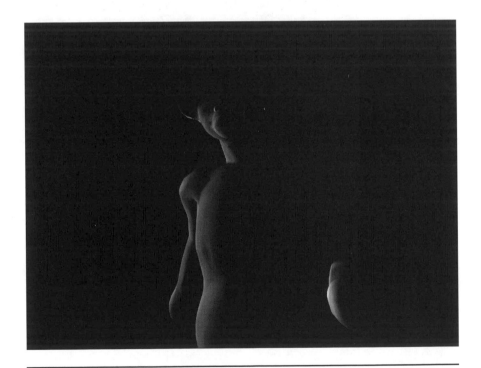

FIGURE 6.3

such lights, this may be all right. However, much of the time you will not have a logical source, so the illumination of the kicker must blend into the overall lighting setup in such a manner that it is noticed only when you remove it. When you look at the hyena with all his lights (Figure 6.4), you don't notice the kicker or eye light specifically. In combination the lights create a consistent image.

Character-Specific Lighting

We have talked about using light to add to a character's dimensionality. Sometimes this is done in the context of the overall lighting

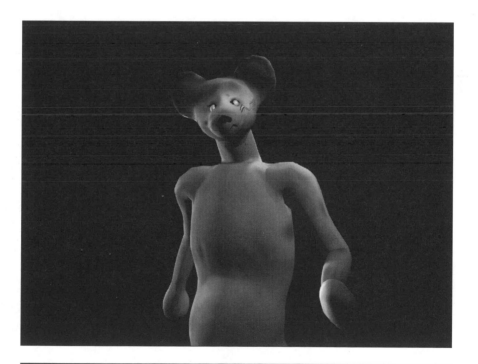

FIGURE 6.4

design for a scene. Other times lighting is created specifically for revealing the personality of your subject. You may choose to use a certain technique consistently to emphasize a trait or point of view.

It is important to integrate character-specific lighting into the scene as best you can. It would look odd if the apparent source of illumination were a lamp on the table but the characters were lit from above or below. Even more incongruous is one character lit from below and the other from above. As you set up your scene, plan light sources that correspond to the character lighting you are using. You don't have to match things perfectly. Audiences do not scrutinize a picture to see if the lighting is consistent. Indeed, if they are involved in what is going on and the lighting adds to the aesthetic effect of the image, your lighting can be wildly illogical. The problems come when the viewers' attention isn't consumed by something else and they begin to look closely at the image instead of following the action.

You must balance the aesthetic with the practical. One way to do this is to be consistent in the way you light all the scenes in your project. Not all the scenes need to have the same lighting setup or even the same lighting concept, but they must have a constant stylistic thread running through them. The style of the lighting must reflect the action of the narrative or the idea behind the images. If you use stylized lighting in the production, you need to stay true to that style throughout. If you change the style of the lighting, then you need a motivation within the story to do so.

Using lighting to color the personality of your character can be very effective. In Figure 6.5, the cat is portrayed as menacing by the placement of the light below his face so that the shadows are cast up. This creates great dark arcs over the eyes, evoking the arched eyebrows of a malicious fiend. The light filtered through the translucent lenses of his glasses adds to this effect by creating additional, less intense shadows over the eyes themselves. A lighting arrangement such as this might be used only in a particular scene to emphasize the menace of that moment, or it might be used consistently to create a general feeling of menace from the cat.

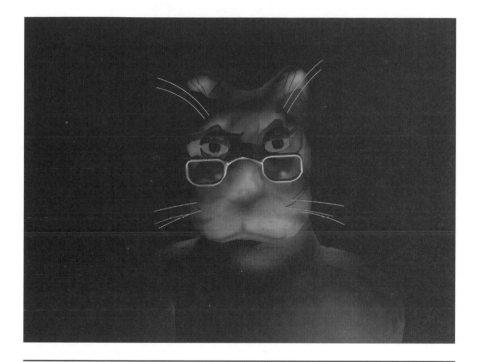

FIGURE 6.5

Framing Characters

When photographing characters you need to consider not only how the lights interact with the character but how the camera interacts with her as well. Earlier chapters discussed how to use the camera to comment on a character's personality. Here we will look at how to frame characters consistently with the action. You must present the subject in a way that concentrates on the important aspect of a scene. For example, if the action is a subtle smile, it is counterproductive to position the camera so that the character's face is hard to see. If the action is a broad physical movement, you don't want the camera framed solely on the face. Sometimes it is important to show

151

the character in the context of a background; at other times you want to separate her from it.

The concepts of camera placement discussed generally in earlier chapters apply equally to characters: Height, roll, and other variables should emphasize characteristics and actions. The amount of the frame the characters occupy is also very important, because you want to coordinate their size on the screen to the action of the moment.

Character shots are classified by how much of the body appears onscreen. They range from long shots, which show the whole body, to close-ups, which show only a small portion. The combination of these shots in a sequence can be a complex dance in which you must take into account not only the content of the scene but also how the shots follow each other in the final sequence. And, if there is more than one character, you also must consider how the shots of all of them interact. Most important, you must make sure that you have the best framing to show the scene's physical action. The camera should be far enough away to see the motion, although you may not want all the action in the frame. The important thing is that the relevant action, which you want the audience to focus on, is as large as possible but still fully visible.

The Long Shot

The long shot in Figure 6.6 shows the whole body of the cat and some space around it as well. This is the shot to use when the focus of the scene is broad physical action. If the cat is doing the lambada, a long shot is appropriate because the action involves his whole body and the expressiveness is revealed by large movements. You might also choose a long shot if the cat is walking, because that is another action that uses the whole body; however, if the cat is talking and walking, you might choose a tighter shot. The relevant action should dictate

FIGURE 6.6

the framing. Thus, if you are using the walk to reveal character, the whole movement should be visible. If the important action is the look on the character's face as he walks, the face should be easy to see—it isn't important to show the whole body just because it is moving.

The Medium Shot

If the cat is walking and talking at the same time or talking and gesturing with his arms, you want to frame both the broad and subtle movements. You need enough of the body in the shot that the physical movement is shown, but you also need enough of the face

to show the subtle expressions. Figure 6.7 is a medium shot. The cat is framed approximately from the waist up, which is wide enough to show the arms and hands. When the cat gestures as he talks, the viewer sees the movements of the hands, yet the face is large enough for the viewer to see the look on his face. This shot corresponds to the view we have of a person when we are conversing with her: usually close enough to see her face but far enough away to see much of her body. Think of the medium shot as the average. When shooting a character you might start with a medium shot and then tighten or widen to focus on the specific action.

FIGURE 6.7

Close-Ups

When you want the audience to see what a character is doing, use a long or medium shot. When you want to show the audience what a character is thinking, get tighter, because the face—the subtle movement of the eyes and the mouth—shows emotion. A close-up is a very tight shot that shows only one part of the character. Most often it is of a character's face, but sometimes you will use close-ups of other parts. You might show only the hand as the fingers tap in impatience, or only part of the face—just the twitch of the mouth or the darting of the eyes. Whatever you focus on, your purpose is to show subtle movement in such a way that it has a big impact.

When a character's face fills the screen, even the slightest movement of the eyes can look big and bold, communicating her thoughts. How do you show a character reacting to bad news? You could frame a long shot of her jumping and flailing, translating the emotion into broad strokes, but often this will seem overly dramatic. How often in the real world do people react to bad news by throwing their bodies around? On the other hand, you might choose a close-up of the character wincing slightly or turning down the corners of her mouth. This subtle reaction connects with the viewer, evoking a memory of similar situations. The slightest physical response implies great internal response. The viewer has experienced bad news and so can project that experience on the character. In general, subtlety of motion can create emotional depth.

In the close-up of the cat (Figure 6.8), we don't see his body at all. Any information we glean comes from his facial movement. The shadows around the eyes become loud statements of character; a twitch of the whiskers indicates malevolence. The audience can get inside his head because they see movements that are big and broad onscreen yet actually very subtle. Making a small movement large gives it significance.

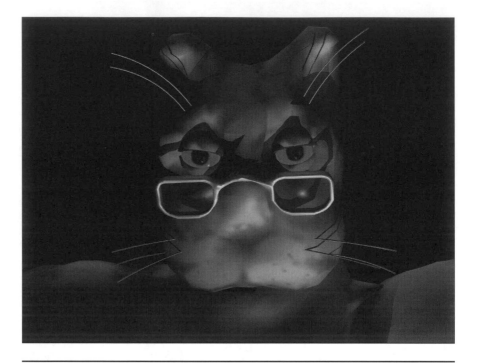

FIGURE 6.8

Dialogue

Dialogue is conversation between two or more characters. In filming it, it is important not only to show the characters individually but also to create a sense of connection between them. If a dialogue sequence is just alternating shots of the characters, the viewer gets no sense of their relation to each other. Therefore, you must create images that show individual characters in the context of shared space. Dialogues usually involve close-ups, medium shots, and sometimes long shots.

Some shots are used in dialogue only when multiple characters interact. Showing both characters at once is important because in the context of a dialogue the audience wants to know not only what the speaker is saying but how the listener is reacting. If the shots simply switch back and forth between the characters it becomes a sequence of talking heads, in which reactions to what each is saying are limited to a verbal response. If we can see some of the listener's reaction, the conversation becomes truly interactive.

In the course of a sequence you will use shots that show both characters. Sometimes both will be in full view, and sometimes only a small part of one will be visible. You will also use shots that show only one character—sometimes medium, sometimes close up. It is not necessary to show all the characters involved at all times. What is important is that you create the feeling that these two people (or cartoons) are interacting directly with each other.

Two-Shots

The purpose of the two-shot is to show two characters at once, both of them equally. With dialogue a two-shot is usually the setup shot. The sequence will start with both characters close enough to see their faces, establishing the physical relationship of one to the other and how they interact. Once this relationship is established, shots of individual characters can be used without a loss of spatial relationship.

In Figure 6.9, the hyena is meeting his old friend Mudboy. The approximately medium shot is framed to show their faces and arms, allowing the characters to interact physically as well as verbally. The blocking of the scene—where each character is physically on the set—affects how tight a two-shot is. If the characters are far apart,

FIGURE 6.9

the shot may have to include their whole bodies to be wide enough to show them both. If the characters are right next to each other, it may go almost as tight as a close-up. The important thing is to establish the interaction.

Over the Shoulder

Another staple of the dialogue sequence is the over-the-shoulder shot, in which one character is shot from behind the other. Over-the-shoulder shots are so called because they always include some part

of the character whose back is to the camera—usually the side of the head and top of the shoulder. The importance of this shot is that it focuses on one of the characters but emphasizes the interaction of the two. One character shows only a bit of shoulder, but this is enough for the audience to get some idea of his reaction. You wouldn't want to do an entire dialogue sequence from over the shoulder of one character. However, interspersed with other shots, including over the shoulder of the other character, this can help maintain the connection of the characters.

The shot over the hyena's shoulder (Figure 6.10) is a close-up of Mudboy's face. Having the back of the hyena's head keeps even a close shot in the context of the two of them interacting. If the hyena is talking, we have a nice view of Mudboy's reaction. If Mudboy is

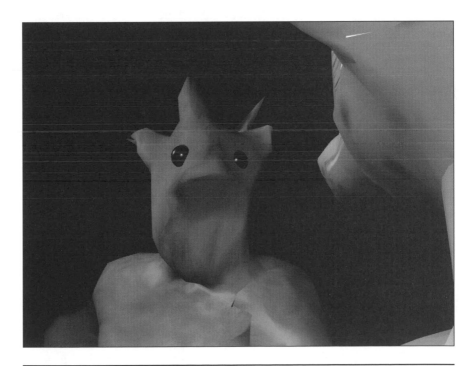

FIGURE 6.10

talking, we still see enough of the hyena to get some sense of how he's taking things. As you get into the meat of a dialogue, you should focus on both characters separately to let the audience see how each is reacting. The over-the-shoulder shot lets you do that without losing the sense of a shared space.

When using over-the-shoulder shots of both characters, as you almost always will in a dialogue sequence, it is important to delineate between the two. If the hyena's shoulder is on the right side of the screen, Mudboy's shoulder should be on the left so that the audience quickly identifies who is where. Both shots with the shoulder on the same side can be visually confusing, especially if the over-the-shoulder shots follow one another in sequence. It is common to cut from one over-the-shoulder shot to the to the opposite shot, and if both are framed with the head and shoulders on the same side of the screen, the cut will be noticeable.

In Figure 6.11, you don't actually see Mudboy's shoulder at all. Mudboy is shorter enough than the hyena that it is an over-the-head shot. Still, this view keeps the physical relationship of the characters onscreen. The shot is also set up so that Mudboy is on the left side of the screen because in the other over-the-shoulder shot they hyena is on the right.

Revealing a Character Through Camera Placement

In Chapter 3 we explored how to use the camera to impart internal qualities to the subject. This is a very important aspect of filming characters, since the more the viewer feels he knows what is going on in a character's head or the role of the character in the scene, the more he can relate to him. The camera should give as much attitude

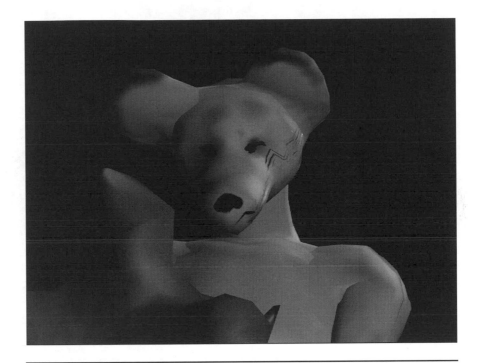

FIGURE 6.11

to your characters as possible. The same character can seem very different if the camera is in a new location.

The cat in Figure 6.12 can take on different roles depending on where the camera is placed. Shot from a low angle, he looks big and imposing, from a high angle (Figure 6.13), he looks small and meek. The only difference between the two is the placement of the camera. As you plan projects involving characters, know ahead what kind of camera treatment you want to give each one. This does not necessarily mean that you will use the same position throughout. You may decide to change the camera's treatment of the character in the course of the story. Particularly if she undergoes a transformation in the course of a narrative, a changing camera treatment can be very effective.

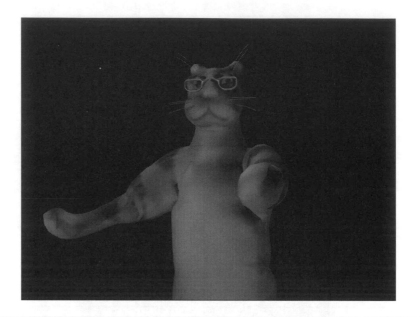

FIGURE 6.12

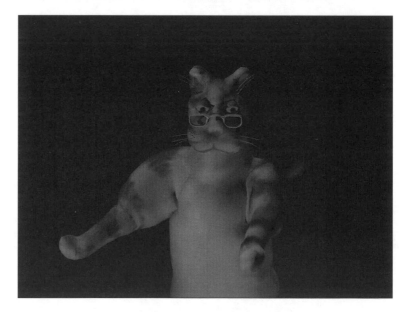

FIGURE 6.13

Moving with a Character

The framing of moving shots is the same as that of still shots—the purpose of a moving two-shot, for example, is the same as that of a static one. The only variable is how the camera will move in relation to the characters. Moving the camera with a walking character is different from moving it with a pacing character. Where the camera is in relation to the characters is another important factor: The camera will move differently in a close-up than in a long shot. Try to minimize the intrusion of the moving camera. The focus is the character, and whatever method of movement complements him the best is the best choice.

Panning

The simplest way of moving the camera is panning, in which the camera changes only its orientation. This is a good way to follow a character who is pacing his office, for example, as he is changing direction frequently. Panning simulates how a viewer might follow the action. If a person were watching this activity in real life, he would stay in one place and follow the movement with his eyes. That is what a pan does. Pans are also useful when you want to track a character but don't want to go with him. At the end of the movie as the cowboy rides off, the camera pans to follow him but doesn't go with him. This adds to the sense that the cowboy is going away.

In the example file on the CD-ROM (hypan.avi), the hyena is walking through a field in a panning shot. The camera's perspective is that of someone observing from a spot in the distance. At the start of the shot the hyena is facing the camera. He walks past until, at the end, we see his back.

Dollying

Unlike a pan, a dolly actually moves the camera with the character. As the character moves forward the camera moves back, always maintaining the same distance from him. A dolly shot will be either in front of the character or behind him, so that the perspective becomes that of a floating, semi-omniscient eye. This is useful when you want to follow the character through the scene or focus on his face as he moves. If you are filming two characters walking down a hall talking, a dolly shot can roll in from of them, keeping them in the same spot on the screen. The main difference between a dolly shot and a panning shot is that the camera remains consistent to the moving character rather than to the static background.

In the dolly shot of the hyena on the CD-ROM (hydolly.avi), the camera maintains its position, moving backward as the hyena moves forward. With a shot like this, make sure that the audience is focused on the action of the character and not on the action of the camera. If the viewer isn't watching the character, he will pay attention to the camera's movement, creating a very self-conscious treatment.

Trucking

Trucking is really the same thing as dollying. The difference is in the camera's position relative to the character. In a dolly shot the camera moves in front of or behind the subject. In a trucking shot the camera moves along beside her. Its perspective becomes that of another character.

On the CD-ROM (hytruck.avi) the hyena walks through the field with the camera next to him. If there were someone beside him, this shot might be that character's point of view.

Wrap-Up

Characters are the focus of any scene. The key to making them work cinematically is to plan their lighting and camera treatment. Consider ahead of time the characters in the scene, and make sure that you incorporate the lighting and camera positions that are appropriate to them. With a little bit of thought and planning your tools can strengthen your characters' presentation.

Several character-specific lights can be used to emphasize various aspects of a character's physical presence. A well-lit character will have more screen impact. The presentation of the character is paramount, and whatever lighting tricks aid that presentation should be utilized. The same is true of camera positions. If you can place the camera so that it reinforces the personality of a character, the whole piece will be stronger.

The interaction of the camera, lights, and characters in a scene is a dance that must be carefully choreographed. Planning how to use your tools and play the characters off one another visually is critical to making a character-based scene work. Keep a consistent visual style and keep it in synch with the narrative. If the visuals enhance the narrative, both will appear stronger.

This chapter focused on how to tailor cinematography to characters. However, characters are usually in environments. We will begin to explore creating environments in the next chapter.

7

Exterior Lighting

Environmental lighting is the creation of real-world light through the use of the cinematographer's tools. In analog film-making, despite the availability of the real thing, photographers often use photo lights to simulate natural light. It is a matter of precision—the more control they have over the lights, the more easily they can create the desired effect. In the world of digital cinematography, the use of artificial lights is a matter not only of precision but of necessity. The computer does not have natural light. There is no sun, and the model of a lamp creates no illumination—all light sources must be simulated. Thus, the art of the digital cinematographer is to make that simulation believable.

The secret to effective environmental lighting is in understanding how light looks in the real world and in learning the cinematic conventions that are used to represent it. Traditional photographers have developed many techniques for using

167

theatrical lights to imitate nature. However, Hollywood has proven that you do not have to precisely duplicate the look of a light source to communicate to the viewer that it is the origin of the scene's illumination; the believability grows in context. Moonlight, for example, is often represented as blue. In reality, the light of the moon is not blue at all, but this convention has become ingrained in the language of film. Viewers have seen many movies in which the light of the moon is portrayed as blue, so they accept it even though it does not accurately imitate reality.

As with all cinematic lighting, environmental lighting is a stylized art. You must use your tools to create an environment that is believable and yet creates the appropriate aesthetic emphasis in the scene.

There are many ways to classify environmental light. Is it interior or exterior? Is it day or night? Is it natural or artificial? Each classification has associated qualities. By knowing and combining techniques that simulate these qualities, you can create any kind of environment convincingly. In this chapter we will look at creating outdoor environments.

Daytime

Sunlight is the granddaddy of natural lighting, illuminating any exterior scene that takes place during the day. Imitating the sun can be very difficult on the computer. Unfortunately, few packages let you simply turn on the sun and go from there. Instead, you must use a combination of lights to simulate sunlight in a limited area.

The basic components of sunlight, in terms of cinematography, are direct light, bounced light, and reflected light. Direct light travels unobstructed from the sun to a surface; it is often the primary light

source in a scene—the key light. Bounced light bounces off reflective surfaces and fills in the darker areas; in effect, it is the fill light and is always soft and omni-directional. Reflected light is like an effect light; it is reflected off a surface, like bounced light, but is hard and unidirectional. Reflected light bounces off shiny surfaces and isn't diffused. Simulating either bounced or reflected light requires additional instruments that create the illusion of reflection.

Fortunately for digital cinematographers, the computer makes it easier to simulate these effects than traditional cinematography does. We can place lights inside the objects that are supposed to be reflecting light, and we can exclude objects we don't want affected by it.

Because the sun is so far away from Earth, the light that comes from it is parallel—that is, its rays do not converge. Directional lights create this kind of parallel lighting. Separate lights must be used to simulate bounced and reflected sunlight. Some rendering engines calculate bounce and reflection automatically, but most calculate the direction of a ray of light only until it reaches a surface, so no bounced or reflected light is created. If you want to simulate the light bouncing off reflective surfaces, you must use additional lights. Keep in mind that it is impossible to completely recreate the physical nature of sunlight; instead, you must try to simplify it while retaining its authenticity.

The inconstancy of sunlight is another crucial aspect in creating a believable outdoor environment. The state of the atmosphere and the time of day have a great effect on the qualities of light: Light from an overcast sky is highly diffuse and casts very indistinct shadows; afternoon light is much harsher, with sharper shadows, than morning or evening light; and winter sun is lower in the sky and casts shadows differently. These spatial and chronological factors must be reconciled with the aesthetic style of the scene. Don't feel constrained by the realities of sunlight, but instead see them as guidelines to help you create the most effective lighting plan possible.

Hard Light

Hard light is not diffused by the atmosphere or by objects between its destination and its source. Sunlight on a clear day is very hard and creates high contrasts—bright areas are brighter, and shadows are darker. The ratio of bounced (basically the fill light) to direct light is very low. In the real world the amount of bounced light is the same whether the primary illumination is hard or soft. When the light is hard, the direct light is so much brighter that it makes the bounced light seem very dim in comparison. Getting the ratio to look right is the first hurdle in creating hard sunlight. It is always important to have some fill light in the scene. Even the hardest light of the noonday sun gets filled in by bounced light.

Hard light also casts very crisp, well-defined shadows. Light travels straight from the sun to the Earth in parallel rays. If the rays are diffused by thick atmosphere, the light scatters a bit and the edges of shadows get fuzzy. Without diffusion the edges stay very sharp. There are two ways to get the crisp shadows of hard light. First, you can use a rendering engine that ray-traces. Ray tracing is a processor-intensive rendering solution that calculates the path of the light rays in a scene and can accurately reproduce the clean edges of the shadows. However, it tends to take quite a bit longer than the second possibility—shadow maps. This technique uses quickly generated maps that simulate the shadows of objects. The rendering is much faster than with ray-traced shadows but also less accurate. To get hard shadows from a map, it is important to increase the map's size. The crispness of the shadow is dependent on the resolution of the map relative to the resolution of the rendered image. The larger the image and the harder the shadows, the greater the resolution needed for the shadow map.

Take a Look

The little stand of trees in Figure 7.1 will be our laboratory for examining the difference between hard and soft light.

In this image the light is hard, casting crisp-edged shadows. Contrast is high, so the dark areas appear quite dark. The main light source is a directional light overhead and to the right that simulates the hard, parallel light of direct sun. Without any bounced light, the scene looks unrealistically harsh (Figure 7.2). When light obeys the laws of physics (which it does not on the computer), some of it will bounce off the ground and fill in the dark areas. The addition of

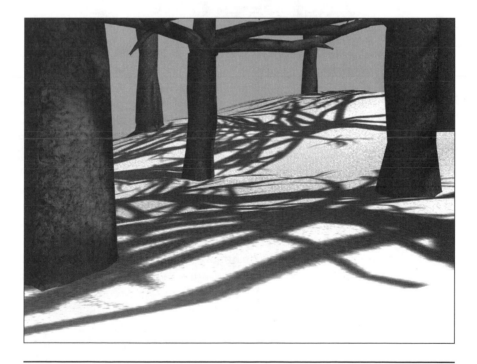

FIGURE 7.1

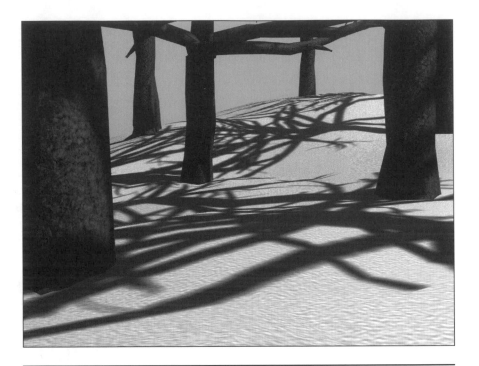

FIGURE 7.2

bounced light will make this scene more convincing to the viewer. To create the bounced light, the fill light in this image is simply placed behind the camera. This adds light to all the surfaces the camera can see. However, if the camera moves in the scene, this solution will probably not work, because the light will not match up with the camera. If the light does not move with it, the camera will quickly reveal the areas not lit by the fill. If the light does move with the camera, the discrepancy between what the light illuminates and what the camera sees will create areas of light and shadow that move on the screen. Multiple lights must be used to simulate the bounced light if the camera is going to move. Nevertheless, the principle is the same whether you use one or multiple lights—add some fill light to the dark areas in the shadows to create a more realistic look.

Soft Light

When there is a thick atmosphere or other interference between the source and the destination of a light, the light becomes diffuse, illuminating the scene more evenly. This is called soft light. Contrast is reduced, shadows are fuzzier and not as dark, and the ratio of bounced light to direct light is higher than with hard light. A real-world example of soft light is an overcast afternoon. At the most extreme levels of diffusion, shadows may become entirely indistinct—with all crispness gone, they become fuzzy dark areas under objects.

Recreating soft light is a two-edged sword. Using shadow maps instead of ray tracing makes it relatively easy to create the soft-edged shadows, but getting the bounced light to look right is more difficult. Contrast helps CGI images look more realistic, adding cues that increase the feeling of depth. Soft-light situations have less contrast and so take more work to make the light look authentic. The basic principle is still to use the fill light to lighten the dark areas of the image, but it must be brighter and smoother than in hard-light scenes.

Take a Look

Look at the glade of trees in soft light in Figure 7.3. The shadows are fuzzy, there is less contrast between the light and dark areas on objects, and the overall lighting of the scene looks brighter and more even. The omni light providing the fill is brighter than it was in the image with hard light. The ambient light in the scene has also been increased to reduce the maximum level of darkness, which lights the scene more evenly and makes things appear flatter. Even in this situation, ambient light must be used sparingly. Although you want the light to be softer, you want to maintain as much contrast as

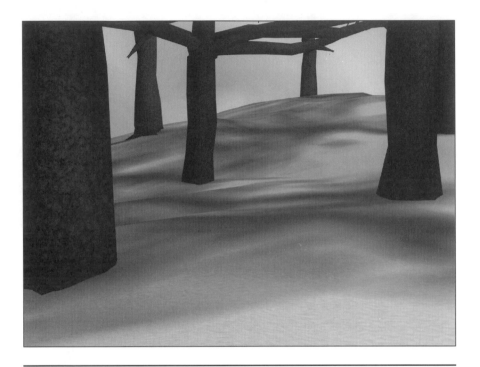

FIGURE 7.3

possible. It is easiest to accomplish this by separating the direct light from the bounced light as you set up.

As you create your soft-light scene, first place and orient the key light that creates your direct light. For the final rendering you will make the light more diffuse, but the position of the key light still determines where the areas of light and dark will fall. Figure 7.3 uses the same key as in the hard-light scene. Now, look back to the image with only direct light (Figure 7.2). In diffuse-light situations it becomes even more important to use the key light to emphasize the dimensionality of the scene. You want to be sure that the play of light and dark on the objects brings out their size and shape.

Once the key light is positioned, turn it off. Working with the fill light independently allows you to concentrate on the scene's dark

areas. Imagine that the scene will be lit exclusively with indirect, bounced light. The concern here is not dimensionality but the amount of detail visible. Because the key light is turned off, you can see exactly how dark the darkest parts will be. The depth of the scene is drastically reduced without the key light (Figure 7.4), but the level of detail visible in the shadows becomes apparent. Even in the darkest areas on the trees you can still see some detail in the bark. Looking at the scene this way, you ensure that the fill light affects all the surfaces seen by the camera.

With both the key and fill lights in place, you can tweak the overall look of the scene. As with any lighting arrangement, once the individual elements are in place you must adjust them relative to each other. You may find that the bright fill light washes out too much of

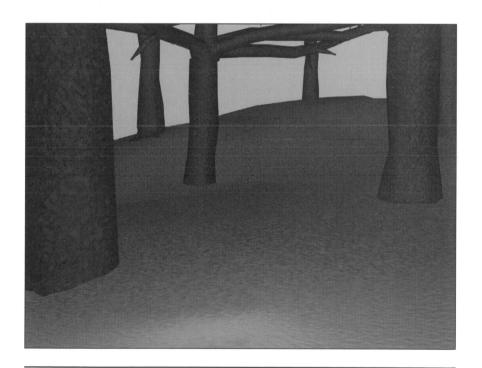

FIGURE 7.4

the scene, resulting in very little contrast. Or the key light may be too bright in comparison to the fill light, creating too much contrast for a diffuse lighting situation. Tweaking the lights simultaneously will allow you to create an effective ratio of direct to bounced light.

Soft Shadows

An important element in creating a believable soft-light scene is soft shadows. In the real world all light, even diffuse light, casts shadows. The more diffuse the light, however, the more diffuse the shadows. In a soft-light situation, the shadows must have soft edges. They still create areas of darkness, but cease to have well-defined shapes.

The computer is remarkably good at simulating soft shadows and uses only two variables to determine their crispness—sampling rate and shadow map size. The sampling rate for the shadow map determines how much the values in the map are averaged. The higher the sampling rate, the more times the computer runs the map through a smoothing process—more smoothing creates softer edges. Unfortunately, higher sampling rates also take longer to render. If you are working in a production situation with a tight deadline, rendering time may be a major factor in determining your methodology.

The other variable in softening shadows actually decreases rendering time; it is one of those rare instances where less is more. If you decrease the size of the shadow map, you decrease the level of detail in the shadows. However, as you reduce the map size, the shadows may become blockier as well. With fewer pixels in the map, the edges can begin to exhibit stair steps, that is, distinct squares of the pixels. The solution to stair stepping is to increase the sample rate so that the computer averages the values in the shadows more and reduces the jagged edges. Creating soft shadows requires a combination of reduced map size and increased sampling rate. One

increases rendering time while the other decreases it, and the net results tend to cancel each other out, keeping rendering times about the same.

Dappled Light

Soft light is diffused by particles in the atmosphere too small to cast shadows. Dappled light is diffused by objects close to the light's destination, which create many small overlapping shadows. Often these objects are translucent, allowing some light through. The resulting shadow covers the ground in a patchwork of varying intensities. The leaves of a tree are the most common source of dappled light, though the slats of a trellis or the bars of a jungle gym might create the same effect.

Creating a dappled look combines the techniques of hard and soft lighting. The fill light is brighter, as with soft light, reducing contrast between the light and dark areas. The shadows are also broken up and less distinct, not necessarily because the light casting them is diffuse but because the objects themselves diffuse the light. The edges of the shadows tend to be crisp, as with hard light, but the overlapping of the objects creates variation in the intensity. This effect is even more pronounced when the objects are translucent, like leaves, allowing some light through.

The leaves on the trees in summer give our little glade a dappled look (Figure 7.5). The intensity of the shadow varies depending on the concentration of objects. Where the trunks block the light, the shadow is deep and heavy. Where the light passes through the leaves, the shadow is broken into many levels of intensity. The play of the shadows gives this kind of lighting a very distinct look. Choreographing characters to interact with the light can create striking images.

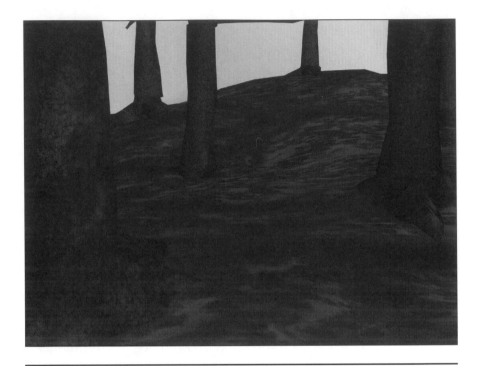

FIGURE 7.5

The lighting in this scene is identical to that in the soft-light scene except for the key light. The shadow map of the key is larger than in the soft-light scene, giving more definition to the edges. A projection map has been added as well. Shadow maps do not take into account the translucence of the object casting the shadow. If you wish to create a dappled look where the variation is due to the translucence of the object, you have two choices. First, you could ray trace the shadows, since ray tracing actually calculates the rays of light and can take the opacity of an object into account. In scenes where the source of the dappling is onscreen, such as when you can see the leaves, ray tracing may be the best option for getting convincing results. The drawback is that it will noticeably increase your rendering time.

The second option for creating the dappled look is to use a projector map. This is a map assigned to the light that filters it at the source. It supports 256 levels of opacity and can be used to simulate light passing through translucent objects. It is very difficult to get projector maps to line up with the objects in the scene convincingly, which can be a problem if the objects are actually onscreen. The best way to deal with this is to create shadows with both the map and the selected objects. In Figure 7.5 the leaves are created entirely with a projector map, but the trunks and branches of the trees cast their own shadows. Without the projector map the shadows of the limbs are still cast (Figure 7.6). By assigning the map to the key light (Figure 7.7), the leaves are added and look convincing because they blend with the shadows created by objects actually onscreen.

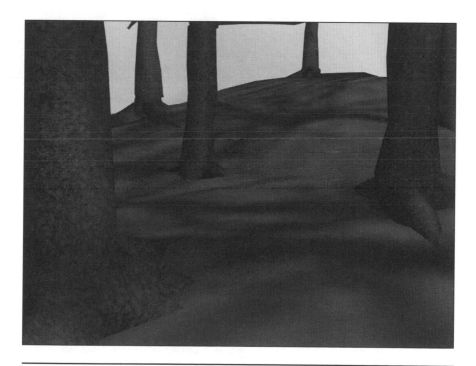

FIGURE 7.6

FIGURE 7.7

Background Light

The background of an image is a big factor in setting the time of day. A light background indicates daytime, while a dark background indicates night. This may seem a bit obvious, but it can have a big effect on your images. If you are creating a softly lit scene to simulate an overcast afternoon, the color of the background can greatly affect the believability of the image. If the sky is too bright, it will not interact convincingly with the lighting. If you are working on a nighttime scene, a dark background helps set the time of day and makes the lighting more convincing even if it is stylized.

PLAYTIME

For the most part, when you are lighting an exterior scene you will not have simply hard light, soft light, or dappled light, but some combination that lies between the extremes. Using all the techniques in combination allows you to tailor the lighting of the scene to the aesthetic and emotional tone desired.

- Create an exterior scene with some shadow-casting objects on a ground plane.

- Try lighting the scene for different situations.

- Experiment with the detail of the shadows and the contrast in the scene.

- Try creating a dappled look with a projector map.

- Combine the projector map with different settings for the shadows and light levels in the scene.

Nighttime

Lighting for nighttime is more difficult than for day. The human eye has an amazing capacity to adapt to low levels of light in the real world. Unfortunately, however, if you simply reduce the light levels when creating an image, the result is a lack of detail that the viewer cannot decipher. To create convincing night scenes, you must fool the viewer into thinking it is dark while maintaining enough detail for her to follow the action. This is accomplished by lowering the light level and adding lights that emphasize the details you want to maintain.

Moonlight

The image of the cat on the fence in Figure 7.8 simulates a moonlit night. The key light has been reduced to half the intensity of a daytime light, and the fill light has been eliminated. Without a fill light the darkest areas of the scene are completely black, which helps to maintain contrast with the reduced intensity of the key light. These light levels are bright enough to include some detail while still seeming dark. The detail is muddy, which is convincing to the viewer because she is used to seeing less detail at night. However, you don't want the subject of the scene, in this case the cat, to get lost in the background. Even in a night scene it is important that the

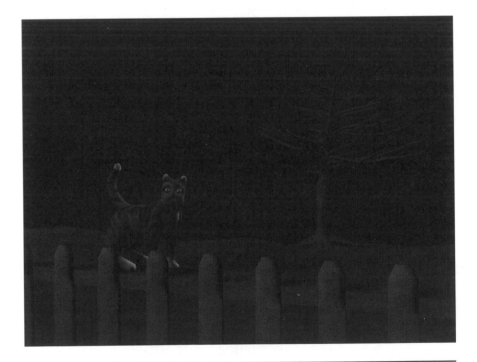

FIGURE 7.8

subject be well defined. To pull the cat out of the background, a back light has been added, creating a line of light that is very thin, almost invisible.

The difficulty with night lighting is that you must keep the viewer from noticing lights that shouldn't be there logically but are necessary aesthetically. If the back light were omitted, the cat's tail would disappear against the night sky and much of the definition of his face would be lost. If the back light were too heavy, it would be obvious to the audience. With night lighting, in particular, it is important to position the back light in such a way that it separates the subject from the background and yet is nearly invisible.

Shadows from moonlight should be very soft. It is tempting to turn off shadow casting for a night scene, but this will create an artificial look. Even moonlight casts shadows—they are just very soft. If you look at the fence, you will notice that each post casts a soft shadow on the rail. Without this subtlety, the scene would seem much more flat.

Pools of Light

Sometimes you will have artificial light sources in a night scene, such as street lamps, that create pools of light in the darkness. This is a much easier scenario to work with than moonlight because you have a logical source for a bright key light and there is no need to trick the viewer into thinking the lit area is dark. You should create very high contrast in this situation. In the real world our eyes adapt to the level of the light—if we are looking at a brightly lit area, an adjacent unlit area will appear much darker than it would if there were no bright light. When you create pools of light, take this into account and make the unlit areas very dark.

Our friend the cat has left his palatial country estate for the big city (Figure 7.9), and we see him poised in a pool of light created by an overhead street lamp. The area outside the pool quickly fades into complete blackness. The only light source is the key light; no fill or back light has been added. The high contrast created by this single-source lighting adds to the nighttime ambiance. The cat's shadow is crisp and distinct because the light source is so close and bright.

If you want to show some detail in the surrounding area, the level of light outside the pool can be brought up a bit, as if a bright moon as well as the street lamp were lighting the street. The moonlight can also be used as a back light to create a silhouette of the city skyline. Darkness alone can also be very effective in creating your images,

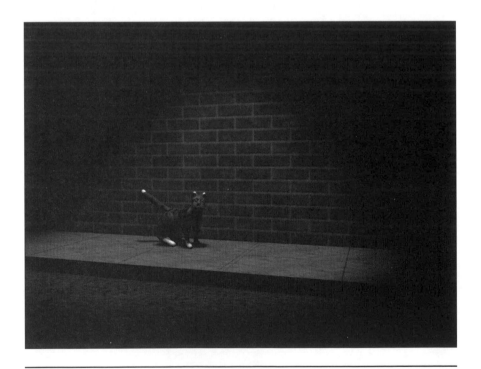

FIGURE 7.9

however. Often what is not seen is more powerful than what is—the sound of a character outside the pool of light (in the darkness) might be much more compelling than the same sound from a visible character. Blackness can also be an important design element. If your intent is that the audience stay completely focused on the cat, eliminating detail outside his immediate area can help. If the cat is lost, a small lit area in the dark might echo his emotional state.

PLAYTIME

A nighttime scene requires a limited number of lights. A low light may be used to simulate moonlight or starlight, and bright light sources may be included. Darkness, however, is the primary ingredient. In experimenting with your own nighttime scenes, see how far you can take the darkness.

- Try creating a lighting setup where a back light is the only separation between the background and the subject.

- Add some pools of light and see if you can maintain the feeling of darkness even when a bright light is present.

- Try to use the blackness as a graphic element in your composition.

TIP: The color of light can be used to indicate the time of day because sunlight changes hue depending on the time; Dawn and twilight often have a pink tone, while midday is white or light yellow; and Hollywood has created the convention of blue moonlight. This can work to your advantage. Realism is subjective—if the viewer accepts something as real, then for your purposes, it is.

Outer Space

Space operas are one of the old standbys in CGI. If you haven't worked on one yet, you probably will at some point. Lighting for outer space is not a radical departure from lighting for exteriors on Earth—it is just more extreme. Brights are brighter, darks are darker.

Outer space is the ultimate single-source lighting situation: The nearest star is always the source of light. The instrument used to simulate this should be a directional light, because stars are so big that their light is always parallel. Also, there is very little fill light in space, except, perhaps, for some small illumination from surrounding stars. High contrast is the name of the game. The dark should be deep and black, and the light should be bright, though the intensity may vary depending on the proximity of the star. Shadows should be very hard since in space there is no atmosphere to diffuse the light.

In the image of the spacewoman (Figure 7.10), the light is a hard directional light to her left. The shadows are ray-traced, giving them a very sharp, clean edge. Ray tracing is particularly well suited to outer space because it creates the hardest possible light. When working on space scenes, you will either use ray tracing or increase your shadow map size as much as is practical to generate the crispest shadows.

Depth of field can be tricky in space. When the key light has a high intensity value, use a very high DOF, because a primary factor in the depth of field is the amount of light. High DOF isn't necessary in space, but it is logical when there is a lot of light. Space scenes are one of the few instances where you may want no depth of field at all. If you can create the sense of depth in your scene without using DOF, leaving it out may add to the sense of vast space.

FIGURE 7.10

 TIP: When composing a space shot, try to break up planar compositions; there is no gravity in space, so not everything should be oriented on the same plane. While some objects, like a fleet of ships, may line up with each other, other objects should not. Viewers are sophisticated enough to recognize that objects in space won't automatically use the same planar orientation. Taken too far, this can create a chaotic, messy feel to the composition, but used carefully it can increase the realism of the scene.

Water

Simulating the effects of light interacting with water in computer graphics is a lesson in fooling the eye. Water itself is a difficult thing to reproduce on the computer. You can imitate the surface without too much problem, but that doesn't create the substance. The trick to lighting water is to make the light and the substance interact. Water bends and filters light more than air does because it is thicker, and this is the property you need to simulate to make water scenes credible. Even if you could filter the light through simulated water, doing so would be very rendering-intensive. Most of the time you will have neither the time nor the tools to create this kind of accurate simulation, but there are tricks that allow you to fake it, and this section will outline some of them.

Reflecting Light Off the Surface of Water

Scenes that occur on or near water require you to imitate light reflecting off the water. With a highly reflective, uneven surface, water creates very distinct reflective patterns that can be seen on objects above the surface. To simulate this efficiently, it is necessary to separate the primary light source from the reflections. Instead of having the light actually bounce off the surface of the water, you fake it with a second light.

In the image of the stand of trees by the lake in Figure 7.11, the light reflects off the surface of the water, creating swirls of light on the trunks. The swirls are made by a projector light with a map. The main lighting in the scene is a standard hard-light setup with a directional light for the key. This illuminates the water, the ground, and the trees, casting shadows. A projector light has been positioned

FIGURE 7.11

under the surface of the water, pointed at the trees, to create the reflecting light. The water object has been excluded from the projector light so that it does not illuminate the surface that is ostensibly generating the patterns.

The angle of the key light is very important to how the projector light is positioned. Light reflects off a surface at an angle complementary to the angle at which it arrives. So, if the key light hits the water at a 15-degree angle, the projector light will need to reflect at –15 degrees so that the direction of the light will be maintained. In the scene, the key light is above and to the right; the reflection is from below and to the right. If the key light were behind the trees, the reflection would point away from them, not illuminating them at all.

The projector light is placed below the surface of the water pointing toward the trees, which gives the light the correct angle. The water itself is excluded. The shore is included in the effects, but because of the angle, the light it receives is imperceptible. Most of the reflected light falls on the trunks of the trees. The scene was intentionally set up this way because the trunks are in shadow and can best show the reflected pattern. There is no reason to go to the trouble of setting up reflected light if it will fall somewhere that is not visible.

The filter in the projector light (Figure 7.12) was created using a turbulence algorithm. Turbulence is a kind of fractal noise.

FIGURE 7.12

JARGON: *Fractal noise* is a random noise pattern generated by an algorithm that uses fractal geometry. A fractal pattern is a pattern that maintains the same characteristics at each level of magnitude. If you zoom in on a small portion, the structure will be the same as it is for the whole. Because many structures in nature are fractal, using fractal patterns in your animation helps to create an organic look.

The reflection off water should look organic; a fractal algorithm like turbulence creates this automatically. If this kind of map were not available, you could paint a similar one in any paint program. However, the advantage of using an algorithmic map rather than a bitmap is that you can animate it more easily. If this scene were part of an animation, the reflections on the trees would move in synch with the surface of the water. To create this effect using a bitmap in the projector would require that the bitmap be animated. The animated sequence would need to be as long as the shot itself, which could be a lot of frames. Using an algorithm, you can set an animation value, automating the movement of the reflection.

Composing a scene that uses reflections off water requires good preplanning. You must coordinate the position of the reflection in relation to the subject in the scene and consider whether the reflection is falling on the character or on the background. You also need to choreograph the action to allow the key light to match with the light in preceding and following shots and have the reflection interact with the set and subject in a meaningful way.

Underwater

Another scene for which you need to simulate light's interaction with water is one that occurs below the surface. Here the light filtered by the water is the primary source of illumination. The same sort of bending and filtering that occurs with light reflecting off water occurs

under it, creating the same kind of turbulence patterns. The amount of light is governed by the depth at which the scene takes place.

Take a Look

In the sample image (Figure 7.13), you see the bottom of the lake discussed in the previous section. The lake is not too deep in this spot, so most of the light from above filters through. The uneven surface of the water above makes a turbulence pattern on the lake bed, created by a map that is very similar to the one used to create the reflected light but with less tonal variation.

FIGURE 7.13

Positioning the key light with the projector map follows the same rules it does on land. As the primary source of illumination, the key light is placed to light the subject of the scene. In the example it is almost directly overhead, as if it were noon. The instrument is a directional light, creating parallel light rays. It is the pattern in the light created with the projector map that makes it appear as if the scene is taking place underwater.

An omni light is used to simulate light reflecting off the light-colored sand on the lake bottom. This is the fill light for the scene. If the lake bottom were dark-colored, much less reflected light would be added to the shot. The fill light is positioned just behind and above the camera.

Fog has been added to the scene to simulate decreasing visibility based on camera proximity. The farther away an object is from the camera, the more fogged it is and, therefore, less visible. This is a very useful trick in underwater scenes. Water is much thicker than air, and the thicker the atmosphere, the more quickly it reduces visibility in the distance. By using a fog effect to simulate this atmospheric interference, you can enhance the quality of your underwater scenes.

PLAYTIME

The most important special effect in creating water scenes is using projector maps to simulate the interaction of water and light. Experiment with this technique in a scene of your own. Take any scene and relight it to make it appear as if it were under the surface.

- See how different sizes and shapes of turbulence patterns affect the scene.

- Try adding additional underwater light sources and coordinating them with the key light.

- Try adding a pool of water to a land-based scene.

- Look at how the angle of the key light relates to the angle of the projector light.

- See how much or how little light you can use for the reflection and still achieve believable effects.

Wrap-Up

This chapter has focused on the techniques used to light exterior scenes, simulating the natural light of the sun and the moon in credible ways. There are many variations on these techniques, and you should try them out. You may also come up with your own. Whatever method you use, keep in mind how light reacts with the environment. The key to creating believable exterior scenes is to make the light act as the viewer expects. Accurately simulating natural sources is one part of this; following established cinematic conventions is another. In the next chapter we will look at the techniques and conventions of lighting interiors.

8

Interior Lighting

Most of the sets you will light are interior, which is both more flexible and more complicated than exterior sets. The advantage of interior lighting is that you can use many more lights, which allows you to sculpt the light more precisely. The disadvantage is that the more lights you have, the more work it takes to coordinate them.

Outside you work primarily with a key light and a fill light. Sometimes you have back lights or effect lights, but these have very specific uses. Inside you can use multiple lights to provide the primary illumination. Rather than a single key light, such as the sun, you may have three or four, such as lamps, overhead lights, and windows. These are easily movable and can be repositioned to cast light wherever you need it on the set. Combining multiple lights creates a subtle, sculpted look, which is difficult to achieve outside.

While you should feel comfortable using unmotivated, or aesthetically motivated, lights on interior scenes, your options for onscreen sources increase greatly indoors. Lamps, overheads, and windows can serve not only as key lights but as back lights, fill lights, or any other position. Logical, motivated light in most of the lighting positions adds realism to the scene.

The shadow and illumination of interior lights can also be combined to create high texture. Patterns of light and shadow can add texture and visual interest to otherwise dull, flat surfaces. The wide range of intensities that can be incorporated in the scene can also be used to focus the attention of the viewer. The light can create lines that lead the viewer's eyes to the subject, or can create pools in which to isolate the action.

In this chapter we will look at interior setups ranging from all-natural to all-artificial light. Sunlight, moonlight, and bounced light will be covered, as will onscreen artificial sources.

Natural Light

I admit there is no such thing as natural light in CGI, but simulated natural light is common. Much of the last chapter was devoted to simulating natural light sources outside. Inside you will often use simulated natural light, but the big difference is that the natural light must have a way to get in. For sunlight or moonlight to illuminate your interior set, there must be a window or door leading outside. This limited entry allows you to control the amount and position of the natural light. The shadows cast by the window frames and other objects create a textured look similar to the dapple effect used outside. Curtains, blinds, or other diffusing substances allow you to use the sun as a source of soft light for your interior.

Indirect Sunlight

To create strong indirect, or diffuse, light you can use a window or a door covered with a diffusing material such as a curtain. In situations where the goal is even, warm light as the primary or secondary light source, this setup is perfect. The diffuse light can be simulated with an omni light, especially if it is combined with other light sources. A spotlight in combination with omni lights for fill can be used if the window is the primary light source.

In the image of the office in Figure 8.1, the primary illumination is the diffuse sunlight filtering through the curtain. This light is, of course, completely simulated. The curtain itself has an illumination map, making it appear as if light is filtering through it. The illumi-

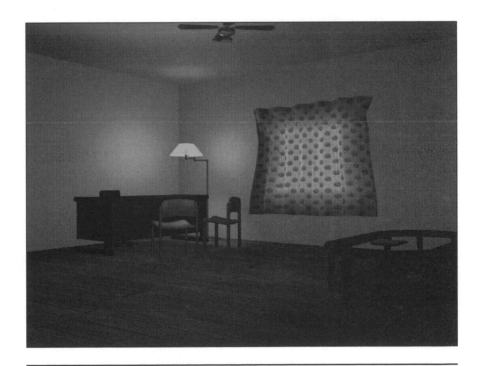

FIGURE 8.1

nation coming from the window is actually created by an attenuated omni light on the other side of the room, and a second, unattenuated omni light, at half the intensity, recreates the light bouncing off the walls and ceiling. The lamp in the corner is a second source of light, its distinct beams created by two spotlights, one for the bottom and one for the top. An attenuated omni light creates the soft light from the lamp.

In the schematic view of the room (Figure 8.2), you can see the omni light that creates the sun from the window. The circles around it show its attenuation ranges—the inner one represents full intensity, the outer one zero intensity. This light does not reach the wall that the window sits in. That wall is lit by the bounced light created by the other omni light.

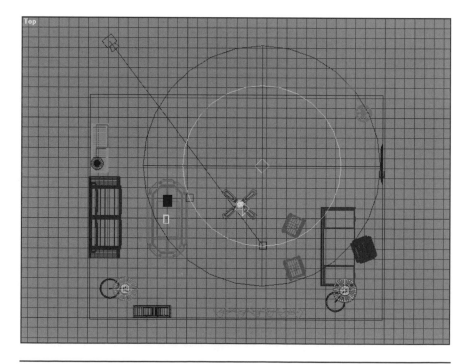

FIGURE 8.2

The ambient light in the scene has been cranked up to a value of 50, keeping the minimum level of illumination in the scene fairly bright. One of the tricks to simulating daytime, especially soft, inside light, is to raise the level of ambient light to a point where even the darkest areas of a room show some detail. The increased ambient light and diffuse illumination tend to flatten the scene, however. Thus, the challenge of a scene like this is that you must maintain a sense of depth without high-contrast lights. Subtle variations in the light intensity become very important. Notice in the image that the intensity of light on the walls is never flat or consistent but has a gradient quality—a change in brightness as it nears or recedes from the light source. This variation is critical in retaining the image's dimensionality.

Direct Natural Light

Direct light, which comes in through a window, door, or skylight, is frequently used in interior lighting. It is created by a motivated source that can be both the key and fill light. The bright, shadow-casting beam through the window establishes a key light, and the diffuse bounced light from the walls and ceiling creates the fill.

The primary factors in making a believable direct lighting scenario are the placement, attenuation, and value of the omni light used to simulate bounced light. In the sample image (Figure 8.3), a directional light has been placed outside the room, shining in through the window, to create the light and shadow on the floor. This establishes the light source in the scene, but doesn't provide much illumination. You can see that without the bounced light (Figure 8.4), the room is too dark and flat for a daytime scene. The light doesn't shine on the wall or the furniture, and the only illumination other than the spot of light on the floor is ambient light, making the objects in the room visible but lacking depth.

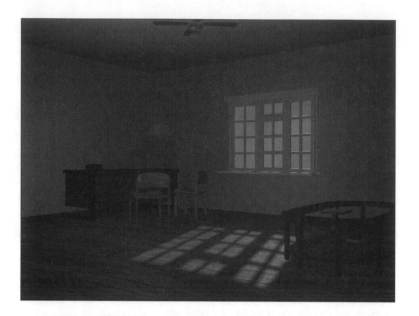

FIGURE 8.3

FIGURE 8.4

The bounced light creates a second believable light source that provides most of the light in the room. Even without the direct light through the window (Figure 8.5), it adds depth. The intensity of the bounced light is about one-quarter that of the direct light, and the ambient light is almost as bright as the bounced light. This creates enough illumination in the scene for everything to be seen and yet allow a lot of contrast with the direct light on the floor.

Contrast, too, is very important in making a lighting setup convincing. Too little contrast and the scene looks flat, too much and the light doesn't look real. The hard light and shadow on the floor in Figure 8.5 establish a sense of depth in the room. The bounced light is dim enough to create contrast, but it also creates depth on its own, enhancing the dimensionality of the scene.

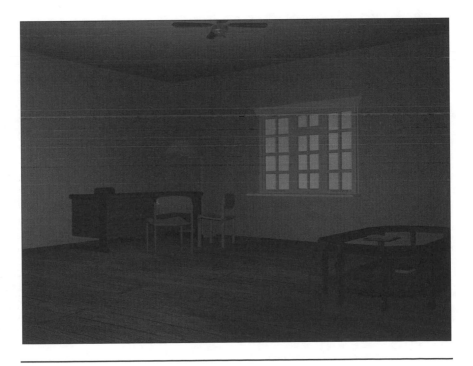

FIGURE 8.5

The omni light's placement in relation to the direct light is very important in creating the illusion that the bounced light is a product of the window's light. In the real world, light coming from outside bounces off the walls, ceiling, and other reflective surfaces, effectively creating the fill light. In CGI, as we have already learned, the light does not actually bounce, so you must use a second instrument to create the illusion. The trick is to get the light to fall in the right places so that the outside light seems to be reflecting off surfaces in the room. In the schematic view of this scene (Figure 8.6), you can see the position and attenuation ranges of the omni light that creates the bounced light in the room. It is placed across the room in front of the window and the attenuation causes it to fall off considerably before it reaches the window wall. The outside light flows from the window and toward the other side of the room, so logically the side opposite the window receives most of the light and the wall around the window receives much less.

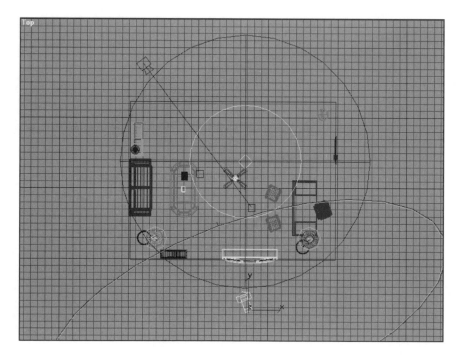

FIGURE 8.6

Direct Moonlight

Creating direct moonlight is very similar to creating direct sunlight. The difference lies in the overall amount of light and contrast in the scene. The moon casts much less light than the sun, so there should also be less light in a moonlit scene. Less overall light also means less bounced light and higher contrast.

In Figure 8.7, the direct light is created by the moon. Here, the direct and fill lights are two-thirds the intensity of the light created by the sun in the previous scene. The biggest change is that the ambient light has been eliminated, so the unlit areas of the scene are completely black. The room's depth is much less than in the daylight scene, which is consistent with the amount of depth seen at night in the real world.

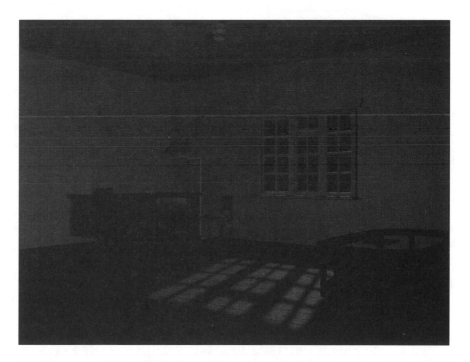

FIGURE 8.7

Making a credible moonlit scene depends on creating the sense of darkness without making the image too dark to see. Contrast is again a key factor. Keeping the direct light bright creates contrast with the dim illumination of the omni light, making it appear even darker than it is. The light from the omni is still bright enough to allow some details of the room to be seen. Instead of the full detail revealed in the sunlit scene, the moonlit scene reveals shapes and outlines. The reduction of detail, combined with the high contrast from the direct light, creates a convincing moonlit room.

Artificial Light

Interior sets usually include some sort of artificial light source—a table lamp, an overhead light, or even a television. Whatever the source, you must use your instruments to effectively simulate the light it casts. Like natural light, artificial light is approximated by a combination of hard, shadow-casting light and soft, diffuse light. Unlike natural light, artificial light tends to be localized. The area illuminated by a lamp, for instance, is very small compared to the area lit by the sun. Artificial light is also not nearly as bright as sunlight, so there is less bounced light to even out the illumination.

Artificial light sources can create many different looks. Where it might seem odd to have two suns lighting a scene, there is no problem having two, or even 20, lamps. This gives you a great deal of freedom in composing the lighting for a scene, allowing you to easily focus the light to illuminate the important areas.

There are two basic approaches to lighting a scene with all artificial light. The first is creating overlapping areas of illumination that shed light on the whole scene. By coordinating the placement of the instruments you can create a high level of light while maintaining tonal variations to avoid a flat image. The second approach is to create distinct areas of illumination that do not overlap, resulting in

pockets or pools of light. As with lighting nighttime exteriors you can use the areas of darkness as compositional elements.

Overlapping Lights

In Figure 8.8, three light sources have been placed so that their lights overlap. Onscreen sources are the table lamp and the floor lamp; offscreen is an overhead light. Each light illuminates only a limited area, but their overlap creates a good deal of tonal variation throughout the image.

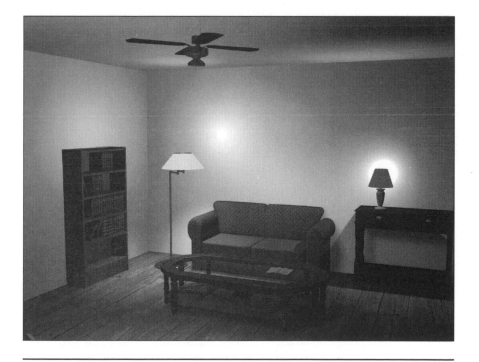

FIGURE 8.8

A slightly different approach has been taken in reproducing each light source. The simplest is the overhead—here an omni light creates some simple fill that allows extra light to come in that could either be from an overhead light or just be bounce light from some other source. Because the source is offscreen and not tied to a location, it doesn't need to be as specific as the lamp lights. The viewer doesn't see the source, nor can she pinpoint its location, so the light's qualities are nebulous and can be adjusted to fit the needs of the scene.

The table lamp uses a slightly different method. As an onscreen source it must behave as the audience expects it to, casting shadows and providing diffuse illumination. The simplest solution to accomplish both these tasks is a spotlight with overshoot. Unlike a normal spotlight, which casts light and shadows inside its cone and no light outside; a spotlight with overshoot casts light and shadows inside its cone and casts its light at full intensity but without shadows outside of it. The spot for the table lamp has its cone pointed downward to cast a shadow from the table; the light it casts on the wall and ceiling is a result of the overshoot. This method has one disadvantage: The light will all be the same value. To be really accurate the light cast through the lampshade should be less intense than the light cast up or down where there is no lampshade, but for this level of realism you need more than one light, as with the floor lamp in Figure 8.1. Realism is not always the most important thing, however. This method provides a quick way to create incandescent light sources that will, for the most part, work effectively.

The method used for the floor lamp produces a more realistic look. Three separate instruments simulate the light it casts: spotlights for the undiffused light emanating from the top and bottom, and an omni light for the diffuse light coming through the shade. Figure 8.9 shows how each light is positioned. The lamp itself has been excluded from the lights so that it doesn't interfere with the shadows cast. The drawback of this method is that the omni light will wash out the shadows from the spotlights a little. Careful attenuation and the use of exclusion can offset this problem.

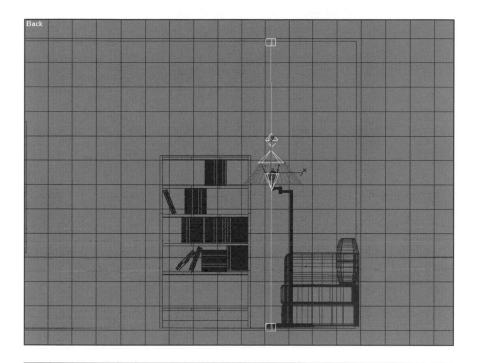

FIGURE 8.9

Each light in this scene illuminates a limited area. The overlapping of the areas combined with the attenuation of each light creates the patterns of light and shadow on the walls and floor. Most of the light is focused on the couch, as this is where a character will likely be. None of the room is really dark, nor is it all evenly lit. The tonal variations created by the overlapping light create a strong sense of dimensionality, with all the details visible and the light concentrated in the most important places. This lighting style is very helpful when a character is moving through the scene. By *blocking* the character's movements you can place lights where he pauses, giving him good illumination when it is needed.

JARGON: *Blocking* is the preplanning of a character's movements through a scene. Figuring this out in advance allows you to place the lights and cameras to best capture his actions.

Pools of Light

Rather than overlapping the areas of illumination in an artificially lit scene, you can use them to create distinct pools of light separated by darkness. The combination of light and dark areas can be a compositional tool. Distinct areas of action can be separated from the rest of the scene by keeping everything else dark, drawing the viewer's eye where you want it.

The techniques for creating the separate light sources are the same as those for overlapping lights. In Figure 8.10, the lamps use the same combination of spotlights and omni lights used in the last example. No overhead light has been included here, keeping the area between the lamps unlit. An omni light with a very low value is placed in the center of the room to simulate a small amount of bounced light. Without the bounced light the area between the pools of light would be completely black, as in Figure 8.11. Sometimes you want that total darkness, but other times a small amount of light adds to the continuity of the image. For example, in Figure 8.11 the center of the image is so dark that there is nothing to indicate that the two pools exist in the same room. The problem is that the viewer's eyes have no path to travel between the two. In a lighting setup like this one, a character will likely occupy each pool. If there is a dialogue or some other form of interaction between the characters, the viewer should be able to look from one to the other easily. Adding just a little bit of light, say illuminating the back wall, gives the viewer's eyes a path to follow as they look from one side of the screen to the other. Such a low level of illumination does not destroy the effect of the pools. Each pool of light still creates a distinct area

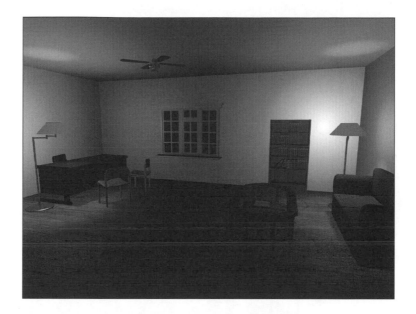

FIGURE 8.10

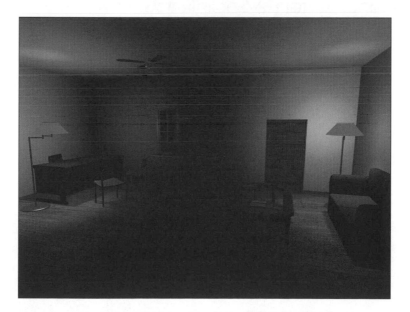

FIGURE 8.11

on the screen, but now there is just enough continuity for the viewer to easily switch focus from one to the other.

Mixed Light

Mixing natural and artificial light is a matter of getting the respective values to combine realistically. The artificial light cannot be too bright or it will make the natural light appear unnatural. The natural light cannot be so bright that it drowns out the artificial light. Finding the compromise is the key to making a mixed-lighting scene work.

Mixing with Moonlight

It is much easier to mix artificial light with moonlight than with sunlight. Moonlight is not as bright, so it doesn't drown out the artificial light as the sun does. Thus, it can be treated as just another light source.

In Figure 8.12, the moonlight combines with two artificial sources: The floor lamp creates a small pocket of illumination in the corner by the desk; a shaft of light, apparently coming through a door from another room, creates a strip of light bisecting the room; and the moonlight streams through the window, casting a shadow on the floor. The moonlight is about the same value as the shaft from the other room; the lamp creates less light than either of the other two sources.

Although it creates a different compositional effect, the play of light and darkness in this scene is similar to the pools of light discussed earlier. There is very little bounced light in the room, keeping the

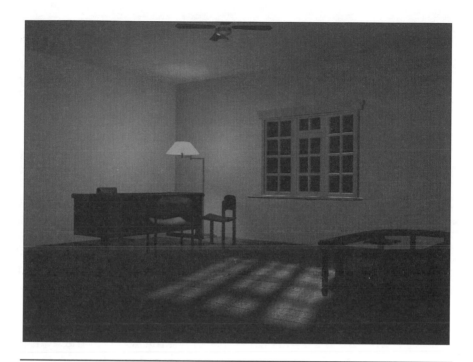

FIGURE 8.12

dark areas very dark. The areas of light don't overlap, except where the shaft of light crosses the moonbeam. Instead of pools of light separating areas of action, the shaft and the window light create a frame around the pool in which the action takes place. If the viewer's eyes follow the path of either the shaft or the window light it will lead them to the intersection of the two. The intersection is placed to lead up to the pool of light around the desk.

The instruments that create the light from the lamp and the window are the same ones described earlier. The shaft is created by a rectangular spotlight. A shadow could be cast by a real doorway, but since the door itself is not onscreen this is unnecessary. With a rectangular spotlight we get the same effect without having to create an actual doorway. A low-intensity omni light creates the small amount of bounced light in the scene.

Mixing with Sunlight

Daylight is so much brighter than artificial light that where the two overlap the artificial light is completely lost. Even bounced daylight is so bright it can overwhelm incandescent sources. The use of artificial lights in sunlit scenes adds a bit of light in shadowed areas. The sunlight will be the key light in the scene; the artificial light will act as a sort of kicker.

In the image of the office lit with a combination of daylight and lamp light (Figure 8.13), most of the light in the scene comes from the sun streaming through the window. It creates the strong pattern on the floor and on the bounced light that illuminates the rest of the room. The lamp adds brightness in the area of the desk. Though not very strong in comparison with the sunlight, it is enough to illuminate the book sitting on the desktop. This is the reason to use artificial light in a naturally lit room—to add just enough light to pull a character or object out from the rest of the scene. If the light from the lamp is too bright, it will not be believable. It is critical to the credibility of the scene that the sunlight appears to be brighter than the lamp light.

PLAYTIME

To get a feel for lighting interior spaces, create one of your own and try different lighting combinations.

- Create an interior set with a window and at least two artificial light sources. Set up a directional light outside the window for sunlight or moonlight. Use spotlights and omni lights to simulate the light from the lamp. Add an omni light for the bounced light.

- Light the set for daytime with strong light through the window. Try changing the angle of the directional light and the intensity of the bounced light to simulate different times of

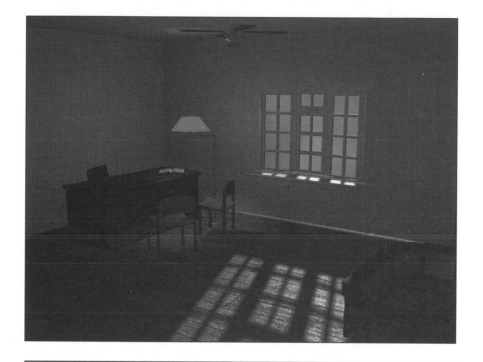

FIGURE 8.13

day and different outside lighting conditions. How does the light change when it is early in the morning? What does it look like when the sky is overcast?

- Add some artificial lights and experiment with their light levels and the level of the sunlight.

- Try lighting the set for night. Combine the moonlight with the artificial light. Try both overlapping light and pools of light.

Wrap-Up

In this chapter you have seen several different techniques for lighting interior sets. The unifying factor among them is creating the right balance between illumination and contrast. Too much illumination decreases contrast, resulting in flat images. Too much contrast makes the light look unrealistic. Cinematographers have been struggling with lighting interiors for over 100 years. No one has come up with the definitive method yet, but by experimenting with the techniques in this chapter you should be able to develop a method that suits your needs.

In the last two chapters we spent some time on simulating various light sources. One aspect not covered was the use of color, for two reasons. First, it is important to understand the principles of illumination without the distraction of color. The way the varying intensities of light combine and react with objects in a scene is the same regardless of the color of the light. Second, had this whole book been in color it would have been prohibitively expensive. However, a little bit of color can go a long way. The next chapter focuses specifically on color and how it relates to the job of the cinematographer.

Color

Since it is likely that all the images you produce as a digital cinematographer will be in color you may ask why we are addressing it as a tool only now, three-quarters of the way into the book. As I mentioned at the conclusion of Chapter 8, one reason is the limited number of color images in the book. However, that is not the primary reason. The art of mixing light to create a compelling image has many layers, of which color is the top. If you peel the color away, the layers beneath remain undisturbed; the concepts and techniques of lighting remain the same whether the color is blue, red, white, or anything else. As a digital cinematographer, you should know how to perceive light without being distracted by the color, thinking only of values and illumination. Color can add a layer to the image, but if the image is not compelling in monochrome the addition of color will not save it. For that reason we introduce color only after a discussion of the underlying lighting techniques.

It may not be the critical factor in image creation, but color is a very important part of the cinematographer's toolbox. It is a powerful tool that can have great emotional effect on the viewer and add to the power of an image. Color can set the tone, emphasize the emotional state of a character, or establish the time of day. Bright colors draw the viewer's eye to a specific part of the scene, whereas contrasting colors draw a figure out of the background.

Color Plans

As a cinematographer, your primary concern with color in a scene is tinting the lights to produce an overall color scheme. The color of the lights combines and interacts with the color of the objects. Randomly combined, without coordination, color can detract from the impact of an image, creating a visual chaos. By orchestrating the color of the lights, the background, the props, and the characters, you can use it as a thematic as well as an aesthetic tool. If you establish a relationship between a particular color and a theme or mood, you can subtly reinforce that theme by reintroducing the color. Thus, associating red with danger allows you to foreshadow a dangerous scene by using red lighting or a red background. Offer the audience a relationship between the color blue and the emotion of loneliness, and you can use the color throughout the scene to reassert that emotion. To show that your character is lonely you might dress her in blue or place her in a blue setting. Such examples are simplistic, but they show that color can add a layer of meaning to your images beyond that of basic lighting.

Choosing Colors

Of the many factors in choosing the colors and color schemes for your scene, the most basic is realism. If you are creating a scene that is mostly realistic, you should choose colors that conform to the viewer's concept of reality. Skies will be blue, grass will be green, and fire will be red. Light itself also has color restraints. The sunlight must match the time of day: At high noon, it will be white or yellow rather than red or orange; firelight will be yellow and orange rather than blue and green. The restraints of realism also demand planning of the overall use of color in a scene. If you know that your primary light source will be a torch, you don't want a color scheme that calls for purple light. If your character has green skin, you may not want to use a green background. The hues of objects and characters should not limit your use of color, but should be factored in as you create a color scheme. By carefully coordinating the colors of objects and lights, you can add to the visual impact without detracting from the realism.

In computer graphics subtlety is not always desired. Color can create a dramatic effect as well. When the aesthetic of your scene is stylized, color can become a tool of pure style, painting your objects and lights in bold strokes. Your choice of hues may entirely alter the emotional mood of an image. One dramatic effect is to change the color of the lights in direct relationship to the emotional state of a character. The scene begins with the character appearing calm, bathed in blue light. When an element of discord is introduced, the light shifts to red and then to yellow as the problem is resolved. Of course, how you relate colors to emotions, and which colors correspond to which emotions, is a product of what you have established

for the audience. You cannot simply decide that green is fear and orange is desire; you must build an understanding of this with the viewer. If the viewer is unaware of the significance of a color it may distract her from the mood of the scene instead of holding her attention on it. Use color in combination with the other cinematographic tools to establish the relationship between certain colors and emotional states. Once the relationship is created in the mind of the viewer, the color becomes an effective tool in its own right.

Picking the Palette

The choice of palette for your scene must be decided in pre-production so that everyone involved is working with the same one. If you don't decide before you begin, you will end up wasting time reworking things to fit. Thus, if your modeler works in a palette of red and blue, and you work in a palette of orange and purple, at some point one or both of you will spend a lot of time recoloring things to coordinate with the other's work. Even if you are working alone, deciding on your palette before you begin building and lighting will save you time and add coherence to your work.

At the start of the production, the key players—the director, the production designer, and the cinematographer—should discuss the use of color: whether the look will be realistic or stylized; which colors will be used to represent each theme or mood; and how the story affects these choices. Go through the script and discuss the colors dictated by the settings and characters to determine a starting point for creating your palette. Thematic use of color can then be added to the mix, as well as the use of color for visual impact alone. The result of these meetings should be a clear choice of palette, or palettes, for the production. When all participants are in accord on the color scheme, put your energy into aesthetics rather than the problems of conflicting color use.

Time of Day

In natural settings the color of light can be useful in establishing the time of day, because the hue of outside light is always affected by the position of the sun. Thus, morning light tends toward orange, while evening light is more pink. The color differences are more effective when combined with changes in position and intensity, but they can nonetheless be a strong tool. The same scene, with variations in light direction and color, can appear to be in the morning, afternoon, or evening. Light can also be an efficient way to show the passage of time. A character sitting in the same place all day can be illustrated quickly by a series of shots in which only the lighting is changed. The sequence might begin with the orange light of dawn, followed in the next shot by the hard, white light of noon, and then the pink hues of dusk, finally ending with the blue tint of moonlight. The passage of the entire day is shown with only four shots, and yet the viewer understands implicitly that time has passed and the character has not moved.

Take a Look

Plates 1 through 4 (see insert) are examples of light illustrating the passage of time. Our friend the hyena has planted himself at the crest of a hill and stays there throughout the day. The first shot (Plate 1) shows him in the early morning. The sun is low in the sky, casting long, soft shadows with its orange light. The time is reinforced by the sky itself, which is not yet fully lit, still holding on to some of the dark tones of night. The second shot (Plate 2) takes us to noon; the sun is overhead, the shadows are sharp but small, and the light has only the slightest yellow tint. In the third image (Plate 3), the sun has moved to the other side of the hill and has taken on the pink hues of dusk. In the last shot (Plate 4), the sun has gone down and the hyena

is illuminated by the blue light of the moon. This passage of time might be shown as a sequence of shots or as a continuous shot in which time is compressed. The choice of structure is a component of the style of the scene, but in either case the effect is to quickly show an entire day's passing.

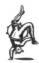 **PLAYTIME**

The sample images of the hyena showed a transition from morning to night, using only the color and position of the lights. Try lighting a scene of your own through this same progression. Don't feel tied down to the methods in the example, but experiment with some of your own.

- Light the scene for morning, noon, and night.

- Experiment with different background images to see how much that affects the impact of the light.

- Try adding some atmospheric phenomena, such as clouds. See if you can still use light color effectively in an overcast scene.

Mood

Using color to establish mood takes more work than using it to show the time of day. Natural light has colors associated with it that the viewer is already familiar with, but there are no hard and fast rules dictating the mood established by any given color of light. Most people have some emotional associations with colors—blue is cold, orange is warm—but to be truly effective it is important to establish the emotional tone of a color within the context of your production.

Other elements, such as camera placement and sound, in combination with color can help the viewer understand what the color means. Once you have associated a color with a mood, changing the color of the light in a scene can change the emotional content.

Take a Look

In the image of Woodrow (Plate 5), all the light in the scene has been given a blue tint, from the key all the way down to the ambient. The tint is strong enough that the white walls appear to be a light blue. Without context, the image does not have a strong emotional resonance, but even in this isolated form the light gives the scene a definite mood. The blue light has a cold quality to it, and the viewer associates this coolness with Woodrow's mood.

Imagine that the script calls for Woodrow to be waiting up for his daughter to return from the prom. There is no dialogue, so the mood of the scene is imparted primarily by the color. Sitting in the cold blue light, Woodrow appears to be calmly, coolly awaiting his daughter's return. He does not seem to be warm and happy; his daughter is late and he is angry with her. In the next scene she arrives home, and he chastises her in a monotone, with teeth clenched. The blue light sets this emotional tone perfectly, showing the viewer that Woodrow is in control but not feeling kindly toward his daughter. The light color foreshadows the more explicit emotions of the next scene.

If, rather than being angry, Woodrow is acting as the kind, concerned parent worrying about his daughter, a warmer light might be a better choice. In the orange-tinted shot (Plate 6), Woodrow seems to be of a kindlier disposition. Here it is easy to imagine that he is waiting up, worried that she is all right. While he might still be angry with her when she gets home, the viewer is likely to interpret

this as parental concern because of how the warm light has fore-shadowed the scene.

The shots of Woodrow are rather crude examples of using color to set the mood of a scene. This kind of emotional foreshadowing is very context dependent and, when viewed out of context, loses a lot of power, but the shots still show a contrast in the emotional tone. Used in conjunction with narrative and sound, this technique is very effective. The coloring of the scene does not have to be as bold as it is in the sample images. Subtle use of color can be effective, espe-cially if it is established throughout the course of the story.

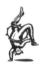 **PLAYTIME**

Try mood lighting in a scene of your own to see what moods different colors evoke.

- Try combining coloring with other effects, such as lighting from below.

- Experiment with subtle variations as well as dramatic ones.

- Use different colored lighting on two characters in the same scene.

Complementary Coloring

Sometimes colored light can be used to solve a problem. For exam-ple, in 3D images contrasting tone on an object is very important in helping the viewer see its dimensionality. If you are working with a large range of tones in your lighting, creating this contrast is easy. If, however, you need to keep the range of values small, because of the

presentation medium or the story's aesthetic requirements, high-contrast lighting isn't always an option. With the contrast in the scene low and the light levels high, there is a big danger of ending up with a flat-looking scene that loses its dimensionality. One solution to this problem is to use complementary colored lights.

When you need to create contrast in a scene but want to keep the final image as light as possible, use complementary colors rather than tonal variation. On a color wheel, the complement to one color is the color 180 degrees around the wheel. The complement of blue is orange, which contains no blue at all; the complement of green is purple; and the complement of red is yellow. Remember that light is composed of red, green, and blue elements, whereas pigment is composed of red, yellow, and blue. Because a color contains none of its complement, there is a natural contrast of hues. A blue key light and an orange fill light creates a contrast that is not dependent on the amount of light hitting the surface, which can help to maintain dimensionality without losing detail.

Take a Look

Woodrow is appearing in a children's show. The emotional tone is light and happy, so it would be inappropriate to use high-contrast lighting, which tends to impart a darker, edgier mood. Despite the desire to keep the scene evenly lit, it is important to have as much dimensionality as possible. To accomplish this, Woodrow has been lit with complementary lighting (Plate 7). The key light is orange, a warm, friendly color, keeping the mood in the scene happy. The fill light is blue, illuminating the areas not lit by the key with a complementary color. The sense of contrast is maintained, but the scene is very evenly lit. If the same levels of intensity are used, but the light colors are not complementary (Plate 8), the scene looks very flat.

Another way of using complementary colors is to separate the figure from the background (Plate 9). Lighting the subject with a blue light and the background with an orange light makes the subject pop forward in the image. The effect in the sample image is dramatic but the same principle can be used more subtly. A low saturation of complementary colors in the lighting of your scene can increase the contrast while remaining imperceptible to the viewer.

 PLAYTIME

Complementary coloring can be a great tool for creating contrast in a scene. Take one of your scenes and adjust the lights so that they are complementary.

- Set the key and fill lights to the same intensity and find out how much contrast you can get solely from color.

- Try using colors that are not true complements but are close, such as blue and red or orange-red.

- Try using the complementary colors very subtly. See if a little bit of color helps your scenes look more three-dimensional.

- Use complementary lighting to pull a character out of the scene.

- Try adding another character, who is not lit with complementary light, and see how the two interact.

Wrap-Up

Color can set the emotional tone of a scene, add contrast to a potentially flat image, establish time of day, or evoke a thematic

element in the story. Despite this potential, however, remember that the effects of color are only one layer on top of many other layers. The coloring must be coordinated with the general lighting in the scene. It can be hard to think in shades of gray as a cinematographer, but that is an important skill. To use color most effectively you must first envision a scene without any. When you have taken the visual impact of the scene as far as possible with tonal variation and visual composition, layering color can take it even further. In practice you probably won't actually compose in monotone and add color at the end, but will work in color throughout the process. What is important is that you don't let the use of color obscure the other tools at your disposal.

In this chapter we have examined the use of color to enhance the effectiveness of the lighting in your scenes. Sometimes lighting, rather than affecting the whole scene, is used to create a particular effect. In these action-packed, high-concept times, you are likely to be called on to create lighting effects. While we tend to think of special effects as having to do with explosions and morphing, much of the effect, especially in CGI, comes from the cameras and lights. In the next chapter you will look at tools for the creation of special effects.

Special Lighting Effects

A bomb exploding, a match being lit, a bug meeting his end in the cruel purple flash of a bug-light—all are scenes that need special lighting effects. In the analog world, flames and similar phenomena create their own light, but with digital cinematography, it is your job to add the lighting effect to these events. The challenge is to create an effect so well synchronized with the physical event that you give the impression that the physical event is generating it.

In creating the lighting for an effect sequence it is important to break the process into discrete parts and, to save time, recreate only those parts that make the effect visually compelling. This saves time both in setting up lighting for the scene and in rendering the final image. The aspects to consider are area of illumination, intensity of light, shadow casting, variation in hue and value, and timing. You probably will not need to recreate all of these qualities for each special effect; certain elements will be

important while others will be secondary. For example, with an explosion you may be able to ignore the shadow casting of the fireball because the event happens so quickly that the viewer isn't likely to notice whether or not it casts a shadow. And when simulating candlelight you can ignore the variation in hue because with a single flame the visual impact is negligable.

Firelight

One of the most common and basic elements for which you will need to create illumination is fire. Three methods are used to create flames on the computer: particle systems, animated maps, and atmospheric effects. However, none of these also creates the light generated by the flame. As a digital cinematographer you must simulate the animated, organic quality of firelight using the instruments you have. To do this it is necessary to divide the effect into different aspects.

Of the three basic attributes of firelight that you must recreate with lighting instruments, the first and most important is flicker—the small change in the direction of light that results in the movement of the shadows cast by the fire. Without it firelight will look unconvincing. The second most important attribute is the shadows themselves. Most of the time a fire in the scene is the primary source of illumination and casts the most prominent shadows. Moreover, in a long shot, where the entire area surrounding the fire is visible, the shadows may need to encompass 360 degrees. The third attribute is the continual change in hue and intensity of the light created by the chaotic movement of the flames. The prominence of each of these attributes depends on both the size of the flame and the scope of the scene.

Breaking the effect down into these three attributes allows you to map out a strategy for creating firelight that is the most effective in

the context of the scene. In other words, the effect's power comes from how it interacts with the scene. A stunningly real firelight effect is pointless if the light doesn't play on any of the scene's objects.

Candlelight

Candlelight is the simplest form of firelight to recreate because the light is localized and the effects are constrained to a small area. It is rarely necessary to have more than one area of shadow from a candle, so the effect can be simulated by a single spotlight. With more complex flame effects, more instruments are needed to complete the illusion.

As explained earlier, the most critical element of firelight is flicker. It is the flickering dance of firelight on the surfaces around it that creates the sense that it is alive. This organic quality makes firelight compelling and recognizable. To create flicker you must randomly move the light source within a set circumference over the course of the animation. Imagine a sphere surrounding the flame; the lighting instrument must move within this sphere to create the illusion that the light and the flame are moving together. The chaotic movement of the instrument can be created by a noise function or random number generator if your software is agreeable. If your options are more limited, the movement can be keyframed manually.

Shadows cast by the moving light emphasize the flicker. The size and extent of the shadows depend on the size of the fire. A candle consists of only a single flame, and a small one at that. The smaller the flame, the smaller the area illuminated and affected by the shadow. Conversely, the smaller the light-emitting area, the larger the shadow in relation to the total amount of illumination. An object will block more of the light coming from a small source such as a candle than it would from a larger source such as a torch in the same location. The more light blocked, the larger the shadow.

Take a Look

The image of Woodrow in Figure 10.1 (candle.avi on the CD-ROM) shows him holding a candle in front of himself. The shadow on the wall behind him, only a few feet away, is huge because his body is very large compared to the light source. Flicker is created by the light source moving randomly around the area of the flame, causing the movement of the shadow. There is no variation of hue or intensity because a single flame emits light constantly. If a breeze were whipping the flame, these variations might be needed to create believable light, but they are unnecessary since the air is still.

The instrument for creating the candlelight effect is a shadow-casting spotlight. A small amount of bounced light is added to account for

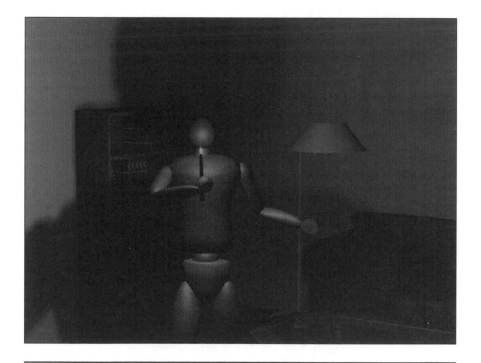

FIGURE 10.1

the reflective quality of the white walls, but these are the only lights in the scene. The shot is framed so that it allows a single spotlight to create the effect. Since the viewer sees only the area of the room behind Woodrow, a spotlight located at the candle's flame illuminates him and the area of the room behind him. If the framing included the area in front of Woodrow, it would be necessary to cast light there as well.

TIP: It is always wise to keep effects as simple as possible while creating an illusion. Adding elements that seem like only a little extra work and rendering time can snowball into a bottleneck over the course of a production. If you are working on an animation that contains 50 candles, 12 extra seconds of rendering time per frame per candle adds 10 minutes per frame to your rendering time overall. You can always add elements to an effect later, if you have the luxury, and doing so is much easier than removing them.

Torchlight

The flame of a torch is much larger than that of a candle because it comprises many individual flames. Creating the light from multiple flames is the tricky part of firelight effects. Although the flames act as a single light source, their individual variations greatly affect the quality of the light. The movement of flame creates flicker, but more flames create not more flicker but less. A single flame's movement is the total movement of the light source, so a little variation can have a great impact. When there are many flames, the movement of each is averaged with the rest to determine how much the light source moves. Small variations nullify each other. Still, onscreen the flicker from a torch may appear very similar to that of a candle because the area lit by the torch is larger. The shadow and flicker are smaller relative to the overall scope of the light, but extend further from the subject than those from a candle. Had Woodrow been holding a

231

torch in the study, his shadow would have been smaller and flick-ered less, and the area lit by the flame would have been larger.

The flames of a torch are larger and more active than the flame of a candle, so the hue and intensity variation of its light must be empha-sized. These elements are not critical to the authenticity of the candle effect, but because the variation is greater with a torch it becomes important to add them. The ideal is a separate light for each flame, each light varying in hue and intensity, but this is not practical because of the setup and rendering times involved. Since the light for all the flames is created globally, by a single light source, the variations must be applied globally as well. Two approaches can be taken in this task. The first is to simply animate the hue and intensity of the light—not wholly accurate but in most cases close enough to be believable. For a more precise simulation, the second approach involves an animated projector map. By applying the animation to the map rather than to the light itself, you can vary the hue and intensity in space as well as over time. The map can include areas of different values, allowing the light to cast multiple hues and inten-sities simultaneously.

Take a Look

Not wanting to burn down his offices, Woodrow has come to the forest to try out his torch (Figure 10.2, torch.avi on the CD-ROM). The space is much larger than the study and can encompass the entire area of effect for the torchlight, falling off into darkness in the distance. Because the scene is framed as a long shot, the torchlight must project 360 degrees. A single directional spotlight was used to recreate the candlelight where less than half the area of effect was onscreen. However, because the cone of light from a spot cannot wrap all the way around, more light is needed.

FIGURE 10.2

Solving the problem of 360-degrees, shadow-casting light depends on the animation software and type of rendering engine employed. If available, an omni light can be used to cast shadows in 360 degrees but not all systems let you do this, and some can do it only with ray tracing, which can be time prohibitive. Multiple spotlights can illuminate all the surfaces affected by the torchlight, but this method also increases rendering time. If the scene is framed so that shadows are prominent all the way around the fire, one of these methods must be used, but if only one direction of shadow will be seen on camera, there is a more efficient solution. In Figure 10.2 the shadows can be seen only behind Woodrow, so the shadow casting need be only in a single direction. A single shadow-casting spotlight lights the area behind Woodrow; the glancing light on the trees in the foreground is accomplished with an omni light, which does not cast

shadows. Casting shadows that will not be seen does not increase the credibility of the effect, but it does increase rendering time.

The hue and intensity variation in Figure 10.2 is accomplished by animating those attributes in the light itself. A more realistic effect can be created with an animated projector map, but for this shot that would not have noticeably enhanced the effect. Just a small amount of global variation, combined with flicker (created by moving the light source), and the long shadow behind Woodrow firmly establish the light as coming from the torch.

Campfire

The light from a campfire is similar to that of a torch, consisting of flicker, shadows, and variation of hue and intensity. The big difference with a campfire, especially if a character moves around it, is that the shadows must encompass all 360 degrees. The same methods for creating torchlight shadows can be used for the campfire.

Take a Look

Woodrow has left his campfire burning while he is off exploring with his torch (Figure 10.3, fire.avi on the CD-ROM). This may get him into trouble with Smokey the Bear, but that is not our concern. The fire is amidst a stand of trees and casts shadows in all directions. The shot is framed so that the viewer can see shadows both in the foreground and the background. Four shadow-casting spotlights used together cast shadows all the way around the fire, each one illuminating one-quarter of the area. If you look closely at the ground immediately around the fire, you will notice four slivers flickering

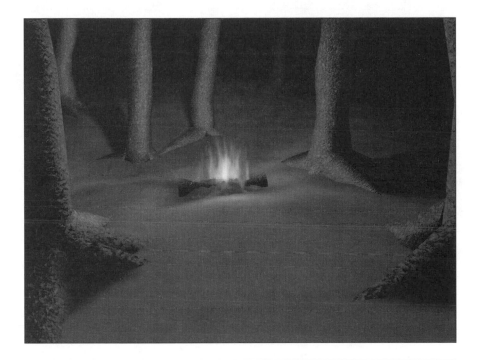

FIGURE 10.3

between light and shadow. Because the lights are moving, their cones do not always abut precisely. When the cones overlap, the area they light is brighter than the rest of the ground; when the cones separate, the area between is unlit. This behavior is a result of using multiple spotlights to create 360-degree lighting. If the slivers of light or shadow are large, they can detract from the effect, but if they are small they will blend in, looking like a natural result of the fire.

Although the spotlights create a complete circle of illumination around the fire, it is still important to position them in relation to the objects in the scene. If Woodrow were present, you would want him to have an unbroken shadow. To accomplish this you would frame him completely within the cone of a single spotlight. If he were standing where the edges of two cones meet, the shadow would be

broken up between the two lights and wouldn't look as real. The number of lights used to create the firelight may vary depending on the number and position of prominent shadow-casting objects. You may need to use five or six lights if there are several objects around the fire that need to cast clear shadows.

 PLAYTIME

The animation of the light source is the key to believable firelight. In creating the effect you must tailor this animation to the setting of the scene. Only the visible part of the field of effect matters. Light one of your scenes with firelight and experiment with different values and scopes for the effect. Don't worry about the flame itself for the moment; just use a stand-in object.

- Light the scene using only candlelight and a single shadow-casting spotlight.

- Relight the scene as if the light were a torch. Add in some hue and intensity variation.

- Try an even larger fire, such as a campfire.

- Look at each of the previous settings with a different camera composition. Make the shot tighter or wider.

- Try different methods for creating 360-degree lighting.

Explosions

With both explosions and firelight the illumination is created by combustion in the scene. However, whereas firelight is an ongoing effect, explosions are dynamic and short-lived. Timing is critical

with an explosion, which is onscreen for at most a few seconds, and much of the credibility of the effect stems from how the light moves in relation to the ball of fire. To make it appear as if the fireball is actually generating the light, you must expand the light's area of effect in synchronization with the expansion of the explosion, creating a brightly lit border all the way around. When the fire dissipates, the light must go as well.

The great intensity and brief duration of the light from an explosion make shadows (critical to firelight) a secondary attribute. The believability of the effect owes much more to the growth and intensity of the light than to realistic shadow casting. In the real world all light creates shadow, so to be ultra-realistic an explosion must do the same. However, as you learned earlier, in the business of effects you want to spend time only on attributes that will make the effect work. If your scene is framed so that its objects obviously cast shadows visible to the camera, you may need to add shadow-casting attributes to the light. If areas where shadows would be cast are quickly engulfed in the flame, you can often get by without shadows at all.

Color variation is also less important with explosions than it is with firelight. The light emanating from an explosion is so intense that it appears almost white and overcomes the other lights in the scene. Variation takes place globally, as the area of effect expands, rather than the locally as in individual flames in a fire. Hue and intensity change in time with the explosion, remaining constant until they fade as the explosion dies.

As with firelight, the space and objects affected by the explosion's light play a large role in the visual impact of the effect. The effect is believable as the light expands on the ground around the fireball, but is very dramatic when an object in the path of the explosion is suddenly brightly illuminated. The initial bang of an explosion has a big visual punch, but placing objects in the path creates additional visual impact, drawing out the effect's intensity over time.

Take a Look

A stick of dynamite has been placed in a field near some trees (Figure 10.4, explode.avi on the CD-ROM). When the dynamite explodes, a fireball blooms, engulfing the nearest trees. The light expands with the fireball and hits the trees only a few frames before the fire. As the explosion dies the light fades.

The light for the explosion was created with the simplest of tools—an attenuated omni light. The scene is framed so that shadows cast by the explosion fall in areas not seen by the camera. The attenuation is animated to correspond to the expansion of the fireball, keeping the sphere illuminated by the instrument always

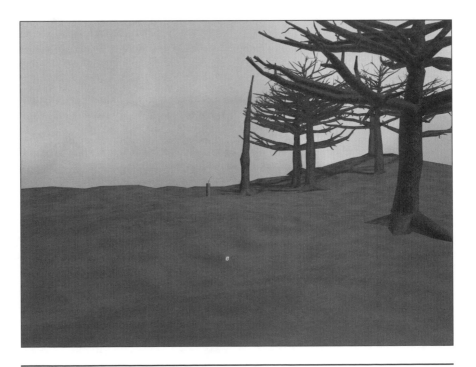

FIGURE 10.4

slightly larger than the ball itself. The intensity of the light generated by the explosion is about five times brighter than the daylight, creating a strong visual impact as it strikes objects.

The light hitting the trees (Figure 10.5) foreshadows the impact of the fireball. The sudden illumination draws the viewer's eyes to the trees just before they are engulfed in flame. The explosion becomes more dynamic because the attention of the viewer moves with the perimeter of the fireball; the consumptive power of the fire is emphasized by watching it overtake the trees. Without the trees, or some other object to highlight the effect, the viewer's gaze would lock on to the starting point of the explosion and follow it lazily outward. The sudden brightness created by the light on the trees jerks the viewer's attention to a new place, not only positioning him

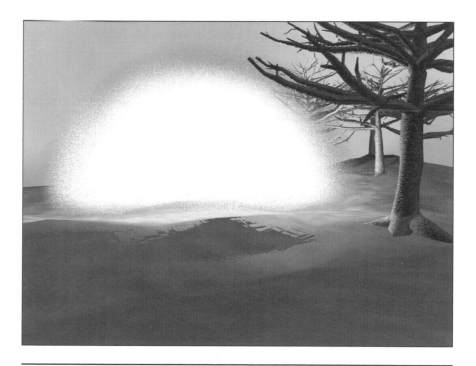

FIGURE 10.5

to see the fire engulf the trees, but also adding to the excitement by keeping the viewer visually active.

PLAYTIME

Set up an explosion of your own. If you don't have a way to create the fireball, use a translucent sphere as a stand-in. Arrange the scene so that there are objects in the path of the explosion.

- Animate the expansion of the fireball and the expansion of the light. Time it so that the light is always ahead of the fire.

- Try different timing schemes. Have the light expand more quickly or slowly in relation to the fireball.

- Play with the intensity of the light; see how bright it needs to be to read well onscreen.

- Add some shadow casting and see if it improves the effect.

- Try moving the explosion above the ground so that the light and fire don't reach it immediately.

Gunfire

The flash of light from a gun is similar to that of an explosion in that it is intermittent, corresponding to the firing of the bullets. Depending on the type of gun, there may or may not be a flash or fireball at the muzzle. If there is, the flash is clearly connected to the firing of the gun by the circumstance and other cues, such as sound. The actual lighting effect is similar to that of a candle—shadow-casting light emitted from a small point—but it is brighter, although not as bright as an explosion. Keep in mind that gunshots during the day

don't create enough light to have much visual impact; in the darkness, however, the sudden burst of light from a gunshot can create a powerful effect. Lasting only a single frame, the flash is the visual punctuation of a dramatic moment. The light pierces the darkness as the bullet pierces the victim.

Composition is very important in making a gunshot visually powerful. Using the flash to light the face of one of the characters for a split second is very striking. The face of the character, hidden in shadow, is suddenly revealed, showing his fear and alarm. The briefness of the flash and the sudden brightness combine to create a kind of freeze frame, the image of the face sticking in the viewer's mind until the next flash reveals a new one. If the scene is framed so that neither the face of the attacker nor that of the victim is visible, the impact is lessened.

Take a Look

Woodrow has been cast against type, playing a mob hitman (Figure 10.6, gunshot.avi on the CD-ROM). The scene is very dark, with only a single light behind Woodrow used to create a silhouette. The darkness of the room emphasizes the visual impact of the flash from the gun (Figure 10.7). Because each flash lasts only one frame, a series of shots creates a strobe effect.

The light is created by a shadow-casting spotlight positioned just in front of the gun's muzzle. Woodrow's face and front are lit, as is the wall behind him. The value of the light is animated, staying at zero except on the frames where shots are fired, when it suddenly jumps to high intensity. The shadow from the flash is not prominent and could probably be removed without much dilution of the scene's visual power. The real power comes from the contrast between the sudden burst of bright light and the darkness.

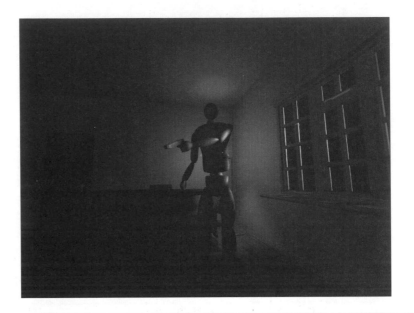

FIGURE 10.6

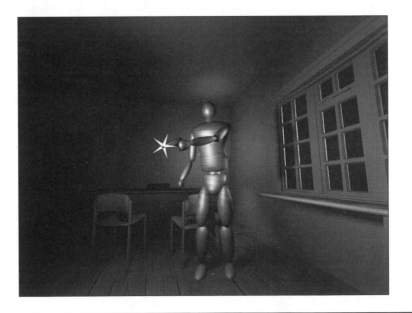

FIGURE 10.7

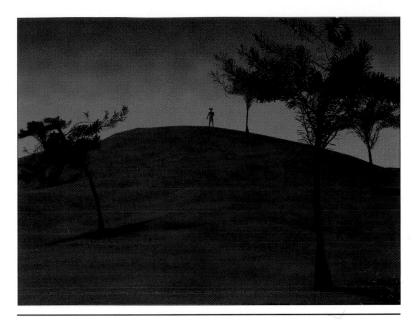

PLATE 1

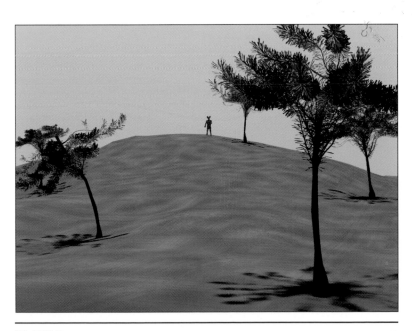

PLATE 2

PLATE 3

PLATE 4

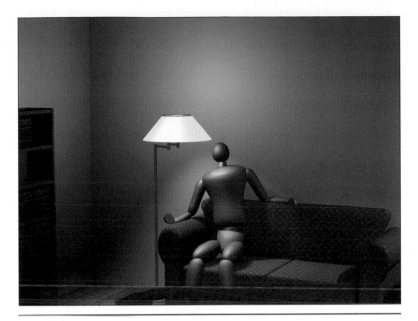

PLATE 5

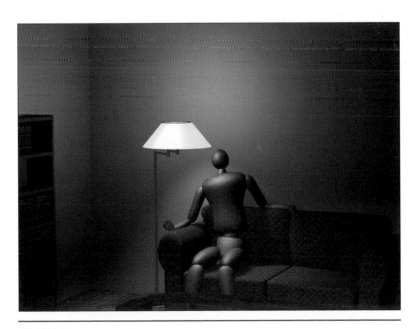

PLATE 6

PLATE 7

PLATE 8

PLATE 9

The flash of the gunshot and the laser we will look at in the next section are both examples of lighting effects that create dramatic moments. Of course, they recreate physical realities, but their real impact is aesthetic. A gunshot without a flash is not a break with reality, as a torch without light would be, but the addition of the flash creates a dramatic effect, increasing the power and tension in the scene.

Laser Light

Laser light, such as that from a laser-guided scope on a rifle, is a simple effect created by a very small, very bright beam of light. Unlike fire or explosions, there are no variables to animate; a laser is simply on or off. Its dramatic impact comes from the movement of the spot created by the laser in combination with the viewer's understanding of what that spot is. With this effect it is important to set the scene for the audience so that they understand what is occurring and can feel the dramatic tension. If the spot of red light from the laser suddenly appears in the scene, the viewer may or may not recognize what it is. If the preceding shot shows the assassin taking aim, however, the viewer will correlate the two and the effect will have more impact.

Take a Look

The red bead of a laser scope moves up Woodrow's body as he sits on the couch (Figure 10.8, laser.avi on the CD-ROM). Viewers know someone is aiming a gun at him and feel the tension as the beam creeps toward his vulnerable spots. The anticipation of a gunshot increases their emotional involvement in the scene.

FIGURE 10.8

The red spot of the laser is created with a shadow-casting spotlight. The hotspot and falloff are identical, making the spot all the same value. Shadow-casting is enabled not because distinct shadows are created but because it prevents the light from shining through Woodrow. The target of the light is animated to create the movement. If the scope from which the beam originates were visible, it would make more sense to link both light and target to it, keeping the direction of the scope and the beam consistent. As the scope is not visible, it is much faster and easier to animate the target along the path of the beam.

There isn't a lot to this effect—no complicated setup or special trick. What is important is that it illustrates the use of lighting instruments to create a dramatic point in the plot. Many of the most dramatic effects are created by using the tools at hand creatively.

Wrap-Up

In this chapter you have looked at using instruments to create light from physical events. Although the several techniques outlined are important, the secret to special-effects lighting is to create a dramatic visual impact. Many methods and effects have not been covered in this chapter. What is consistent throughout all of them is that simulation of reality is only half the game. An effect that is visually accurate but not visually compelling is a waste of time. The art of the digital cinematographer is to use her tools to transform the lighting or camera work into an aesthetic component of the scene.

Effects lighting uses lights to create very localized phenomena, tailoring the light to the composition of the scene. Often CGI artists are called on to create scenes where the camera moves freely, changing composition. This requires a lighting strategy that does not depend on the placement of the camera. In the next chapter we will examine lighting for a 360-degree field of vision.

Games

Video games use all the tools and techniques discussed in previous chapters to create a believable and aesthetic simulation. However, allowing players to choose their own paths through a game scene creates unique challenges for the digital cinematographer. For instance, the lighting must be designed not only for one but for all possible camera positions. Also, the digital cinematographer is responsible for covering up any mistakes in the modeling and texturing of objects. As production schedules are usually very tight, it is often more practical for you to hide mistakes than fix them. In this chapter we will look at these two challenges and discuss ways to deal with them.

360-Degree Lighting

Most of the time you light a set for a specific camera position. However, sometimes you will design lighting that allows the camera freedom of movement, as in a *real-time* game in which the lighting design must work equally well from any direction. The first-person–perspective game MYST is a good example of such a game. Although the player does not have total freedom of movement in MYST, there is a 360-degree point of view at each camera position, which you accomplish with still images, one for each direction, that abut each other at the edges, and join seamlessly. While it would be possible to light and render each image separately, this is not practical because of the time constraints of most production schedules and the importance of seamlessly matching the edges. Instead, you should create these images from a single scene and lighting setup.

JARGON: *Real-time* refers to games or other applications that render 3D graphics on the fly. Rather than rendering only certain images of a real set, the program allows the viewer to navigate freely through a virtual set. At present, real-time rendering engines work only with low polygon scenes that do not contain a lot of complexity.

Lighting for a free-roaming camera is difficult because it must be consistent regardless of where the camera is pointing. Motivated light sources are important to this lighting design because the viewer is able to turn around and see the light's origin and is therefore likely to spot a discrepancy if the light does not have a specific source. An unmotivated light may add an effect to the scene, but it must be used subtly.

Each motivated light performs the function of several lighting tools and positions—the key for one side of the scene will be the back light for the other side, and other lights act as the fill and kicker. It is easiest to understand this type of lighting by dividing the set into

separate areas. If the scene contains only one light, it is treated as one large area; if it contains eight lights, there are eight areas, and so on. The lit areas may overlap extensively, eliminating the sense of separateness, but the idea of lighting different areas of the set with different key lights remains the same.

The most difficult aspect of lighting 360-degree navigable environments is simulating reflected or bounced light. Usually you recreate bounced light with a point light that generates light at a single point in space. For a single camera position, the light can be placed behind the camera, affecting all the surfaces visible through the lens, but this is not an option in a freely navigable environment. Instead, the bounced light must be approximated in a fashion that works equally well from any camera position.

Multiple lighting instruments are used to accomplish realistic bounced light in a user-controlled camera environment. The lights are spaced evenly throughout the environment, and each instrument's area of effect overlaps those of the other instruments. Every spot on the floor receives light from multiple directions simultaneously, simulating real bounced light reflected from the myriad surfaces in the scene.

Take a Look

Following in the long tradition of cheesy fantasy adventure, the sample environment I've chosen for your examination is a torchlit cave (Figures 11.1 through 11.4). The enclosed space makes it easy to show the techniques of 360-degree lighting. The same principles can be used in a more open environment; however, the bigger the environment, the more lights are needed and the more complicated things get. Your job, as always, is to make the lighting convincing, but now you must do this in all directions, from all possible camera positions, factoring in both believability and aesthetics.

Figures 11.1 through 11.4 show a 360-degree camera position. Four cameras, each with a 90-degree field of view, are placed at the same position pointing north, south, east, and west, respectively. The total FOV is 360 degrees, and each 90-degree camera view matches at the edges with the cameras on either side. Most freely navigable game environments have several such camera positions per location, or are real-time rendered, allowing the user to go wherever she likes.

In the sample scene, the light from each torch is created by a spotlight with both attenuation and overshoot. Attenuation limits the effect of the light to a specific sphere around the spotlight; overshoot allows the light to act as both spot and point, lighting areas outside the cone of the spot with non-shadow-casting light. With these two attributes, the pools of light around the torches will overlap in some instances and not in others. The scene's bounced light is created by four attenuated point lights placed around the outside of the cave walls. Since the lights do not cast shadows, they shine through the walls. The attenuation range for each light is set to include the whole cave, with intensity dropping from 100 percent at the near wall to 25 percent at the far wall.

 PLAYTIME

When you design for 360-degree environments, most of your light sources will be onscreen and motivated. To make sure that the lighting works in all parts of the set, you need to have a camera that moves through it or a series of cameras that encompass the whole area. Take a scene that uses a motivated light source as the key light and relight it as a fully navigable environment.

- Make all the light sources in the scene onscreen and motivated.

- Light the scene sectionally, using overlapping pools of light.

FIGURE 11.1

FIGURE 11.2

FIGURE 11.3

FIGURE 11.4

- Try creating the bounced light in the scene with a single point light.

- Add more point lights, one at a time, until your bounced light looks convincing.

- Animate a camera meandering through the environment, to check the navigability of the lighting.

Covering Up Mistakes

It is three days until the Alpha version of your game goes to the publisher. All the production departments are scrambling to get their pieces of the game done in time. At a meeting the art director notices that the map on the brick wall doesn't look good—it stretches at the corners. The modelers throw their hands in the air and huff that they have no time to go back and fix the walls if they are going to get the sewer monsters finished on schedule. The art director agrees and tells you to fix it.

Your job as a digital cinematographer will include cleaning up other people's mistakes and oversights. The production of computer games (or any production, for that matter) often requires that short-comings of models, initially thought to be irrelevant, be disguised. It may be that the mapping on a model was designed to be seen only from one side but now you see from two sides. Or a model originally intended only as a background piece may now be in the foreground. Whatever the situation, you must use the tools at your disposal—the lights and camera—to hide the unsightly mistake.

There is no set of techniques that will fix every modeling problem you encounter because each situation is unique. Many methods may be employed, separately or in combination, to suit each crisis. The guiding principle in all cases, however, is simplicity—the cheapest,

easiest solution is usually the best. If there is a flaw in the mapping on the tree trunk, the easiest solution may be to place shrubs around the base of the tree. When one side of a spaceship looks bad, you may be able to turn it around and use the other side. If the modeler forgot to give Fred feet, perhaps you can show him only from the waist up. Whatever the problem, try to solve it quickly and simply; usually that's all you have time for.

When confronted with a first-aid job that can't be solved by moving an object or keeping part of it offscreen, remember that shadows and cameras are your best fix-it tools. For example, changing the angle from which your camera views the scene can solve many problems. A small change in camera direction can totally change how a particular object appears onscreen. You may be able to reposition the camera so that the offending object is now obscured by another object or so that the flawed element is no longer a prominent feature. How much you can change the camera angles varies from scene to scene, and sometimes it may not be an option at all, as in real-time environments.

When changing the camera angle isn't viable or doesn't completely fix the problem, the next line of defense is placing and manipulating shadows. This can get more complicated than camera manipulation because it may force you to alter the overall lighting of the scene. Before you do that, consider whether there is a way to add the shadows you need without changing any other lights. Sometimes a new light can be added to create the shadow you need without adjusting the lights already in the scene, or adjusting them only minimally. Even an entire redesign of the lighting plan may be the simplest solution in some situations—sometimes it is easier to redesign the lights completely rather than struggle to get a new light to work in the old design.

Another method to consider is fake shadows. Rather than adding a shadow-casting light, it may be easier to use a negative light to remove illumination from the problem area. If the flaw is already partly shadowed, you can use a negative light to darken the existing

shadow so that the flaw is hidden. Even if the problem area is not in shadow, you may be able to simply add a fake shadow. Using a projector map in a negative light can shape your fake shadows to make them blend in with the scene. If the scene already contains shadows from trees, for instance, you can shape the fake shadow to look like light through leaves. If the fake shadow is consistent with other shadows in the scene, it won't be obvious that it isn't motivated by a light source.

Take a Look

In the sample scene, Leo is singing on the street and is seen both in a long shot and in close-up. Signals got crossed in production and there are some obvious flaws. In the long shot (Figure 11.5) the texture on the brick wall is obviously stretching where the wall protrudes. In the close-up (Figure 11.6) Leo's mouth is just a map rather than a geometric shape.

The problem of the stretched brick wall can be solved by adjusting the camera angle to be more perpendicular to the wall, as in Figure 11.7, which reduces the size of the stretched area onscreen. The flaw is not completely hidden, but its prominence is reduced. The camera could be adjusted further, completely hiding the stretching, but this would lead to a very flat composition. Also, instead of using only the camera to fix the problem, try a combination of camera angle and lighting changes to maintain the compositional strength while still achieving the necessary first-aid. The other flaw in the scene will require some adjustment to the lighting, so you can kill two birds with one stone.

The problem with Leo's mouth must be fixed with lighting. The modelers, in their infinite wisdom, designed him to be seen from afar, creating his mouth with only texture and bump maps. Unfortunately, bump maps don't change the model's topology; they create

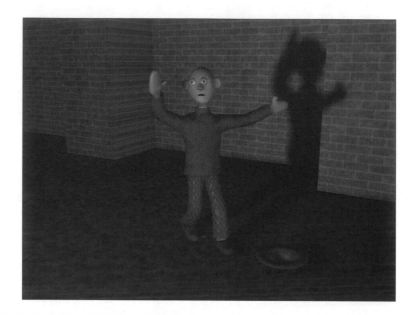

FIGURE 11.5

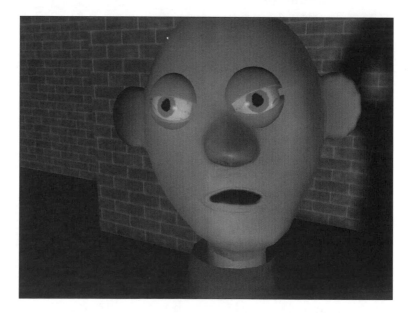

FIGURE 11.6

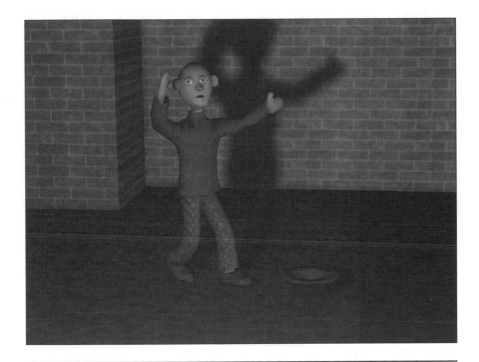

FIGURE 11.7

an illusion of structure and depth by affecting how the light falls on it. When seen in close-up, the lack of actual geometry is obvious. The only way to make an existing bump map look better is to adjust the lights to emphasize it. Light that strikes a bump map from an angle increases the map's effectiveness by allowing it to create more shadow and tonal variation.

In the original close-up (Figure 11.6) the light strikes Leo's face head-on, lighting it evenly. Because bump maps are only the illusion of structural detail through shadowing, flat light can be a deadly enemy because it decreases depth even when there is real geometrical detail and can virtually nullify a bump map's effect. To make Leo look as convincing as possible, the light needs to be more angled, creating more tonal variation in his face.

257

In the revised close-up in Figure 11.8, the key light has been moved higher and at more of an angle in relation to the camera. This creates more shadow on Leo's face and allows the bump map to have a greater impact. It does not hide the fact that the mouth is mapped onto the face, but it makes it look as good as it can, given that limitation. Ideally, a character appearing in close-up has all the important structural details created with geometry rather than mapping, but when the job at hand is visual first-aid, you simply make the best of what's there.

Adjusting the light for Leo's mouth has also solved the rest of the stretching problem on the brick wall (Figure 11.9). The new light position casts less light on the section of the wall that stretches, leaving it in dark shadow. The combination of the shadow with the adjusted camera position effectively hides the mapping flaw.

 PLAYTIME

Create a scene with flawed models or pretend that the models are flawed. Either way, pick some elements in the scene that need to be de-emphasized. Set up an initial camera position that exposes the areas in need of first-aid. Using only the camera and lighting, make the scene look dynamic while covering up the flaws.

- Adjust the camera position to hide the flaws in the model.

- Find another position, as different from the first as possible, that hides the flaws.

- Return to the initial camera position and try hiding the flaws using light only.

- Try using a negative light.

- Find the most elegant, simple, and effective combination of techniques to cover the flaws in the scene.

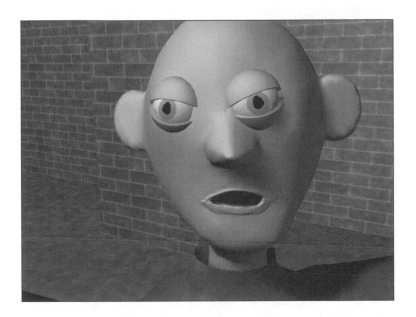

FIGURE 11.8

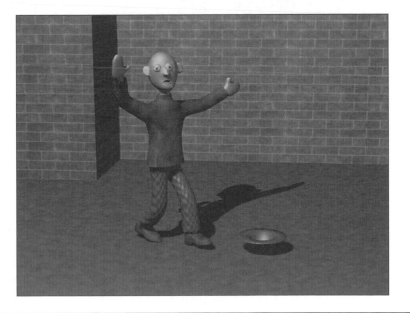

FIGURE 11.9

Wrap-Up

This chapter has focused on the digital cinematographer's tools for creating user-navigable environments and for fixing modeling and texturing problems. In both cases we have focused on specific problems and have fixed them with the simplest tools possible. This is the guiding principle of the digital cinematographer: Whether you are working on a game, a TV show, or a printed image, your job is to get the best results in the shortest time with the least effort.

Closing Thoughts

This book has provided you with an introduction to the digital cinematographer's toolbox. However, knowing how to use these tools does not instantly make you a craftsman. The heart of the job is continual problem solving. Solutions may be simple, like positioning a light to act as the sun, or difficult, like simulating news footage. In either case you must create a solution that fulfills the goal of the project. The Playtime sections in previous chapters were presented not only as ways to help you learn specific tools but to get you in the habit of finding more than one solution to a problem. There are always different ways of achieving a particular cinematic effect, and success grows from choosing the one most appropriate to the project at hand.

As a digital cinematographer you must never lose sight of your specific goals. If you are working on a real-time project and are limited to four lights, making the scene look great using six lights doesn't help. A smooth, softly lit scene has no place in a gritty action game. One of the greatest pitfalls for a cinematographer, or for any artist, is to become enamored of your work. You must be utilitarian. No matter how beautiful a shot is, if it doesn't achieve its practical

and aesthetic goals, it is useless. Look at your work with an objective eye and ask yourself if it does the job. You may end up cutting your favorite shot out of the scene because it isn't appropriate, but on the next project you'll know how to do it correctly.

If you want to improve your skills, you can do two things: watch and practice. There is a wealth of reference material all around you by other artists, from television and movies to video games. If you study carefully, you can learn the tricks of the trade. Sit down in front of the TV, turn on any movie, and analyze what the cinematography adds to the film and how it was achieved. If you don't like the look of the movie, figure out why it doesn't work for you. If you are particularly impressed by an effect, rent the video and watch it over and over until you can see how the effect was done. Then put it into practice. Pick an effect or style that you like and try to recreate it on the computer. Figure out how to use the tools at your disposal to achieve that particular style. Analyze the effect and break it down into its components. How many lights are in the scene? Does the camera move or is it stationary? What length lens is used? If the answers to these questions are not immediately apparent, try different solutions until one works. Don't be afraid of failing. This is a process of trial and error, and you will fail several times before you succeed. Remember, the learning that comes from doing, trying, and failing teaches you infinitely more than not trying, and great success is almost always preceded by failure.

Now, go forth and make pretty pictures.

Index

About AP Professional

AP Professional, an imprint of Academic Press, a division of Harcourt Brace & Company, was founded in 1993 to provide high quality, innovative products for the computer community. For over 50 years, Academic Press has been a world leader in documenting scientific and technical research.

AP Professional continues this tradition by providing its readers with exemplary publications that bring new topics to light and offer fresh views on prominent topics. Often, today's computer books are underdeveloped clones, published in haste and promoted in series. Readers tend to be neglected by the lack of commitment from other publishers to produce quality products. It is our business to provide you with clearly written, educational publications that contain valuable information you will find truly useful. AP Professional has grown quickly and has established a reputation for fine products because of this commitment to excellence.

Through our strong reputation at Academic Press, and one of the most experienced editorial boards in computer publishing, AP Professional has also contracted many of the best writers in the computer community. Each book undergoes three stages of editing (technical, developmental, and copyediting) before going through the traditional book publishing production process. These extensive measures ensure clear, informative, and accurate publications.

It is our hope that you will be pleased with your decision to purchase this book, and that it will exceed your expectations. We are committed to making the AP Professional logo a sign of excellence for all computer users and hope that you will come to rely on the quality of our publications.

Enjoy!

Jeffrey M. Pepper
Vice President, Editorial Director

Related Titles from AP PROFESSIONAL

WEXELBLAT, *Virtual Reality Applications and Explorations*

YAGER, *Multimedia Production Handbook*

YOUNG, *Introduction Graphics Programming for Windows 95*

YOUNG, *Windows Animation Programming with C++*

Ordering Information

 AP PROFESSIONAL
An imprint of ACADEMIC PRESS
A division of HARCOURT BRACE & COMPANY

ORDERS (USA and Canada): 1-800-3131-APP or APP@acad.com
AP Professional Orders: 6277 Sea Harbor Dr., Orlando, FL 32821-9816

Europe/Middle East/Africa: 0-11-44 (0) 181-300-3322
Orders: AP Professional 24-28 Oval Rd., London NW1 7DX

Japan/Korea: 03-3234-3911-5
Orders: Harcourt Brace Japan, Inc., Ichibancho Central Building 22-1, Ichibancho Chiyoda-Ku, Tokyo 102

Australia: 02-517-8999
Orders: Harcourt Brace & Co., Australia, Locked Bag 16, Marrickville, NSW 2204 Australia

Other International: (407) 345-3800
AP Professional Orders: 6277 Sea Harbor Dr., Orlando, FL 32821-9816

Editorial: 1300 Boylston St., Chestnut Hill, MA 02167 (617) 232-0500

Web: http://www.apnet.com/approfessional

About the CD-ROM

The CD-ROM packaged with this book contains digital animation video sequences that are meant to supplement the figures and text within the book. The CD-ROM can be read by either a PC running Windows 3.1 or greater, or a Macintosh running System 7 or greater. Each video sequence is included in two formats, .AVI for Windows, and .QTM (QuickTime) for Macintosh. .AVI files can be viewed on Windows using the application mplayer.exe (an application included with Windows), while the .QTM files can be viewed on the Macintosh using QuickTime.

The images in this book were created and rendered in Kinetix's 3D Studio Max using an Intergraph TDZ300 workstation.